HUE COLORING

Magic Is Something You Make
Hand Lettering, Creative Coloring and Inspirations

ISBN-13: 978-1544994413
ISBN-10: 1544994419
Copyright © 2015 Hue Coloring
All rights reserved.

No part of this publication may be copied, reproduced in any format, by any means, electronic or otherwise, without prior consent from the copyright owner and publisher of this book.

IN THIS COLORING BOOK...

48 Creative Hand Lettering designs are included in this adult coloring book to help you relax and make your life more colorful. These illustrations are created for you to bring enjoyment to your life, and designed with beautiful patterns that appeal to adult eyes.

TIPS TO A FUN COLORING

Find a quiet space. It's easier to focus on what you are doing when there are no distractions.

Organize your materials. Lay out your coloring book and crayons, pens, or pencils.

Set the mood. Turn on some tranquil music, diffuse lavender or another relaxing oil, and make sure you have your preferred drink at hand.

Select your picture. Which image speaks to you today? That's the one you should color. Choose your palette. Select the colors you will be using for your image.

Begin coloring. This is the fun part. Don't worry about getting everything perfect; just start. If you feel you don't want to do it anymore, just stop!

SHOW US YOUR CREATION!

We'd love to hear from you, show us what you created.
Facebook: www.facebook.com/huecoloring
Pinterest: www.pinterest.com/huecoloring

Please be sure to subscribe to our newsletter by visiting: huecoloring.com. We'll show you our latest coloring projects as well as giving you information of the best deals.

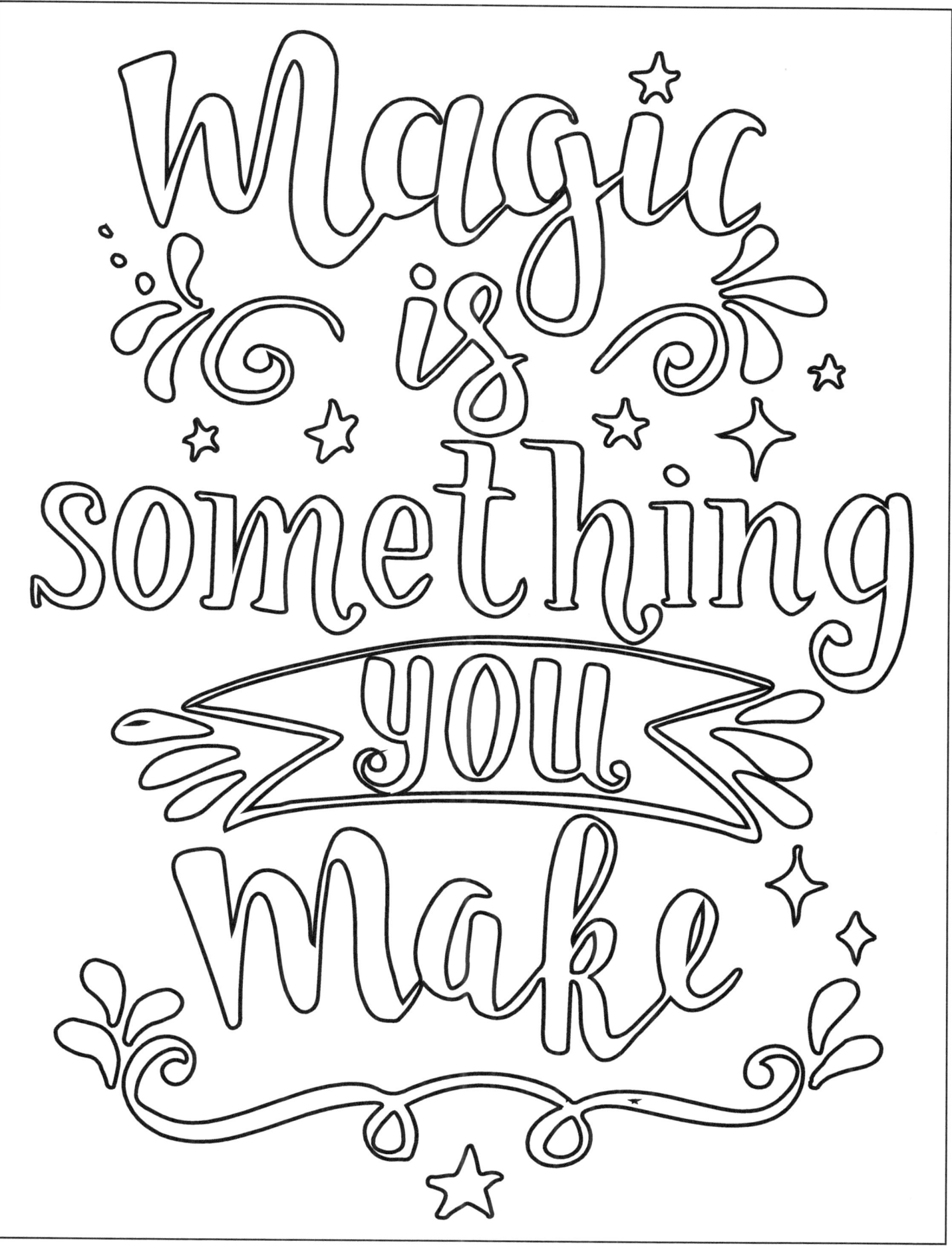

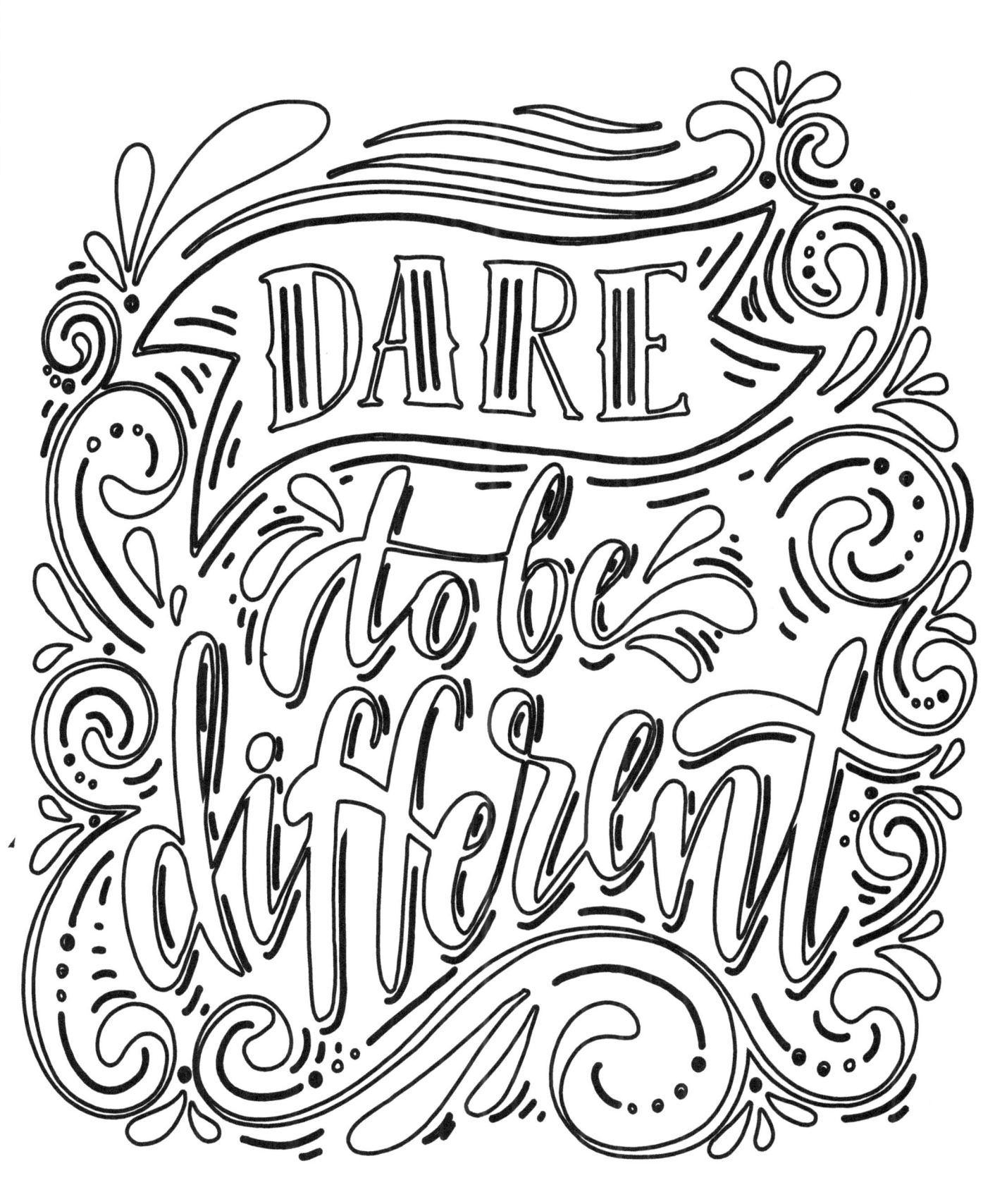

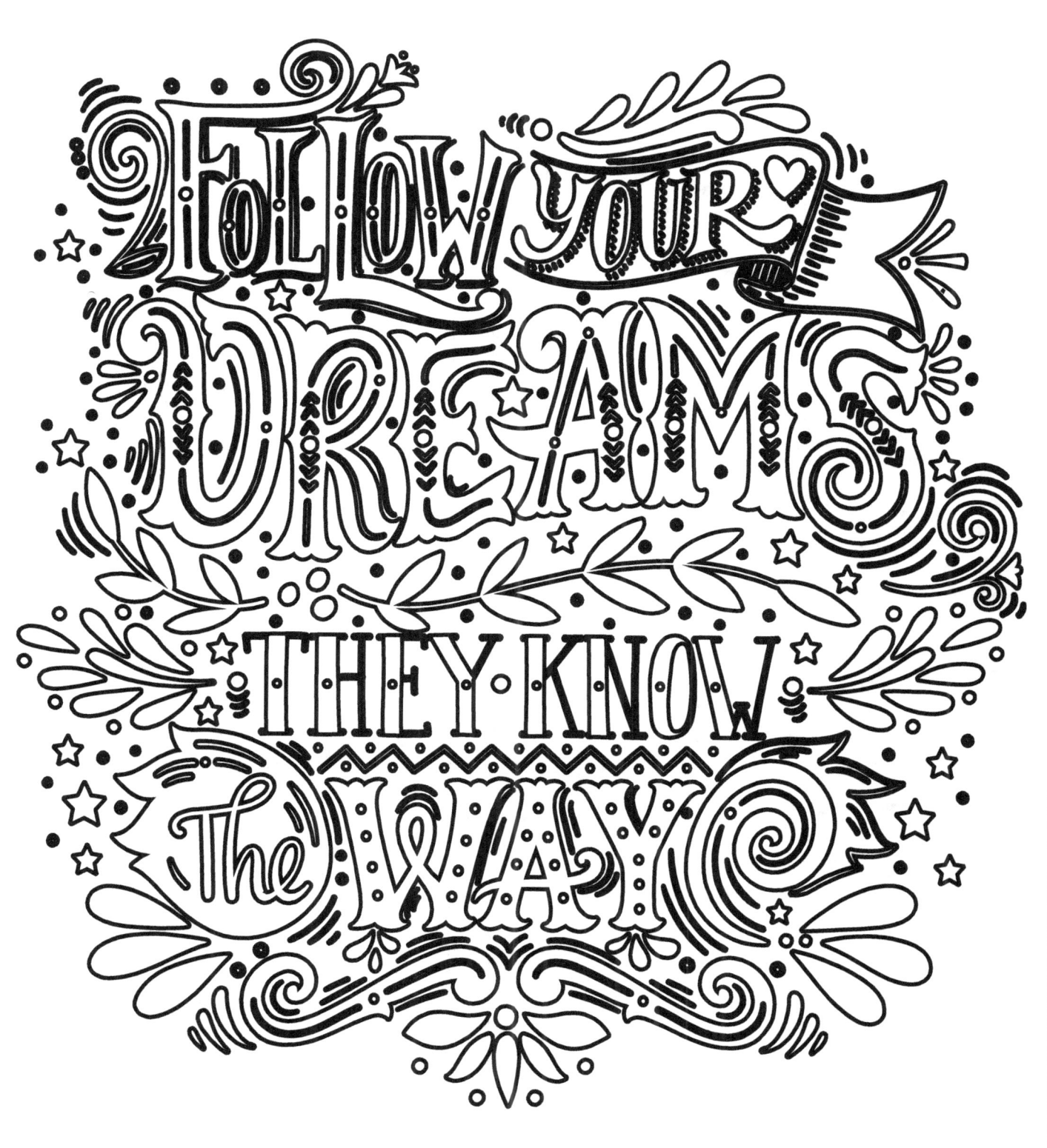

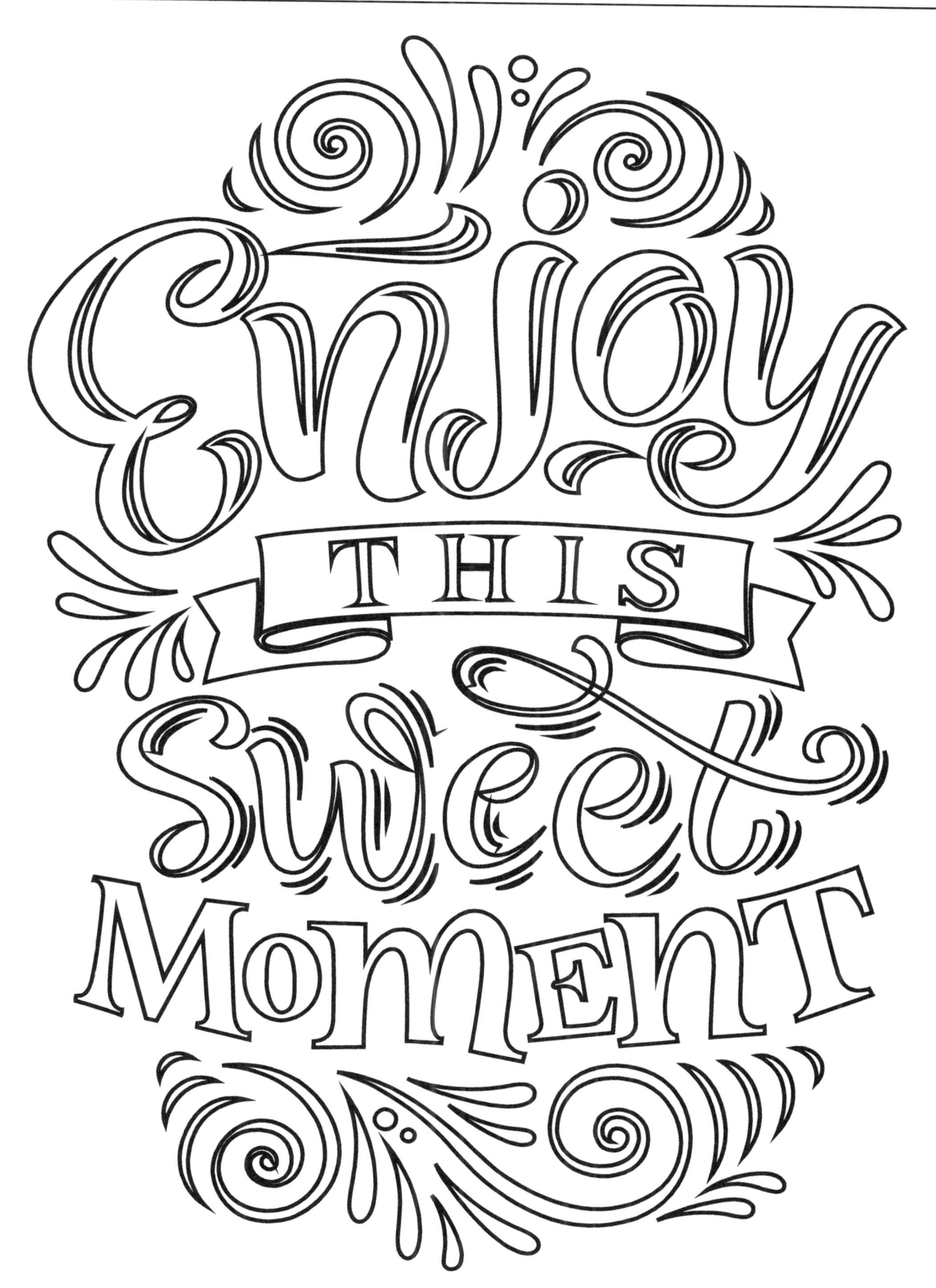

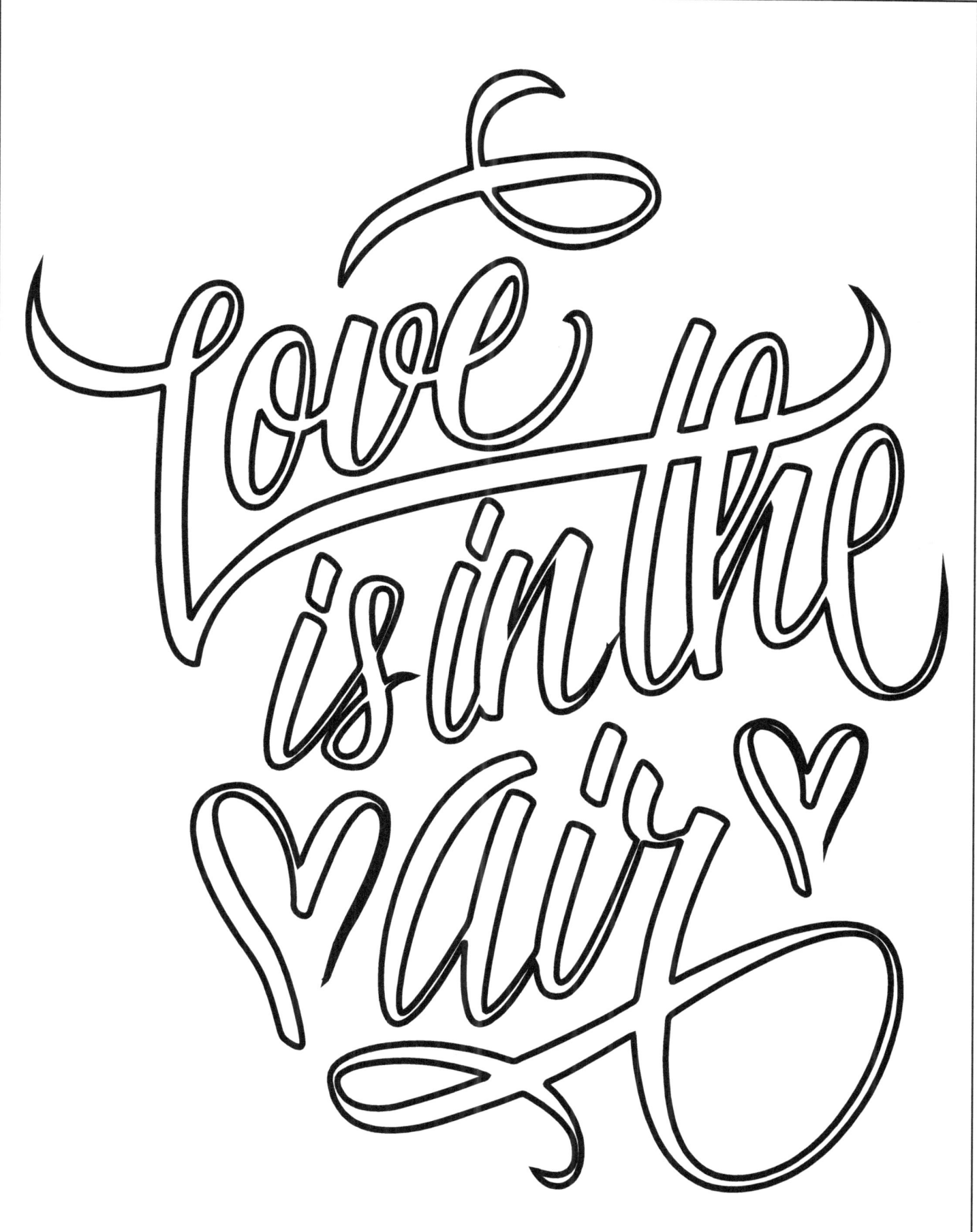

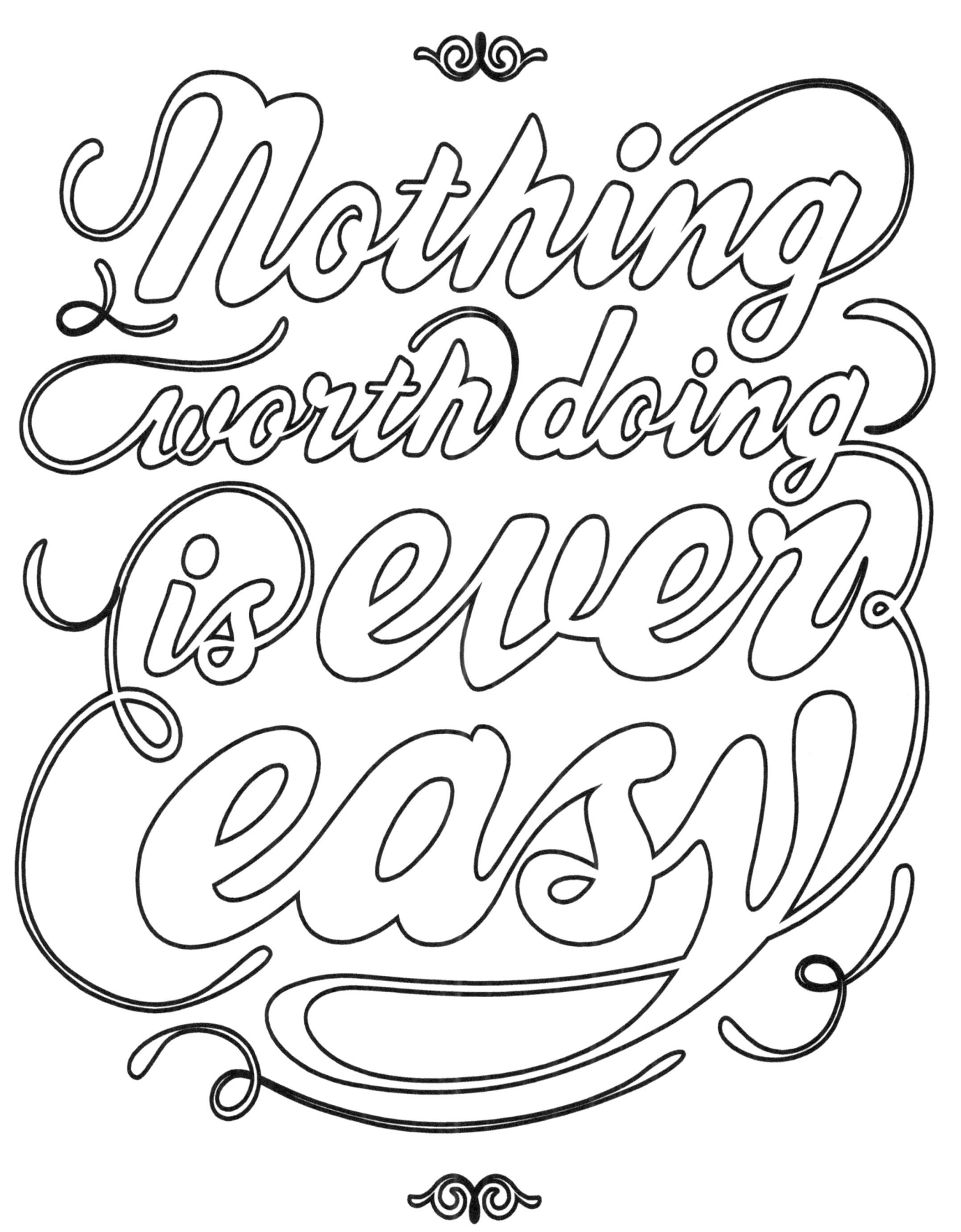

GIVE THANKS WITH A GRATEFUL heart

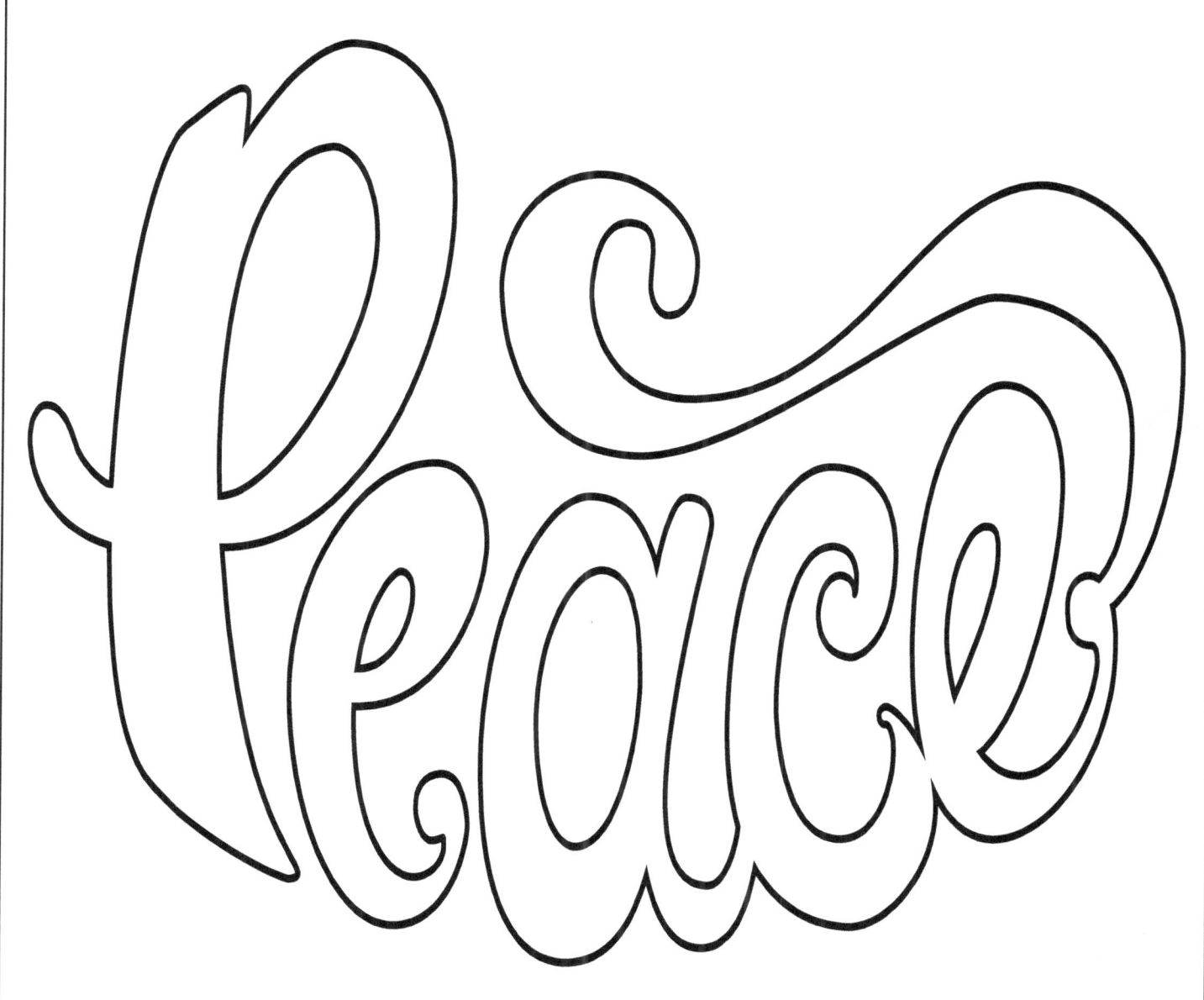

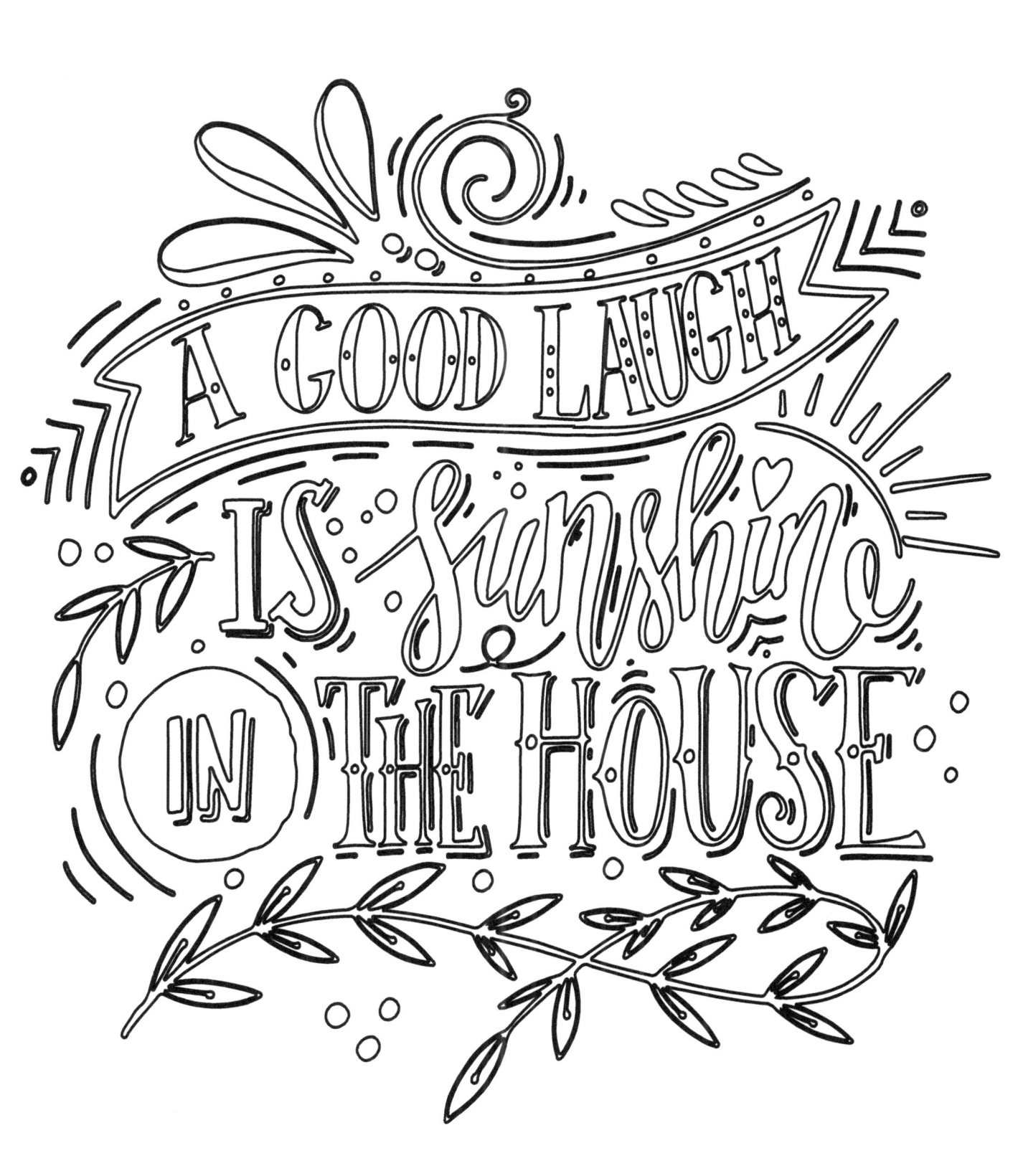

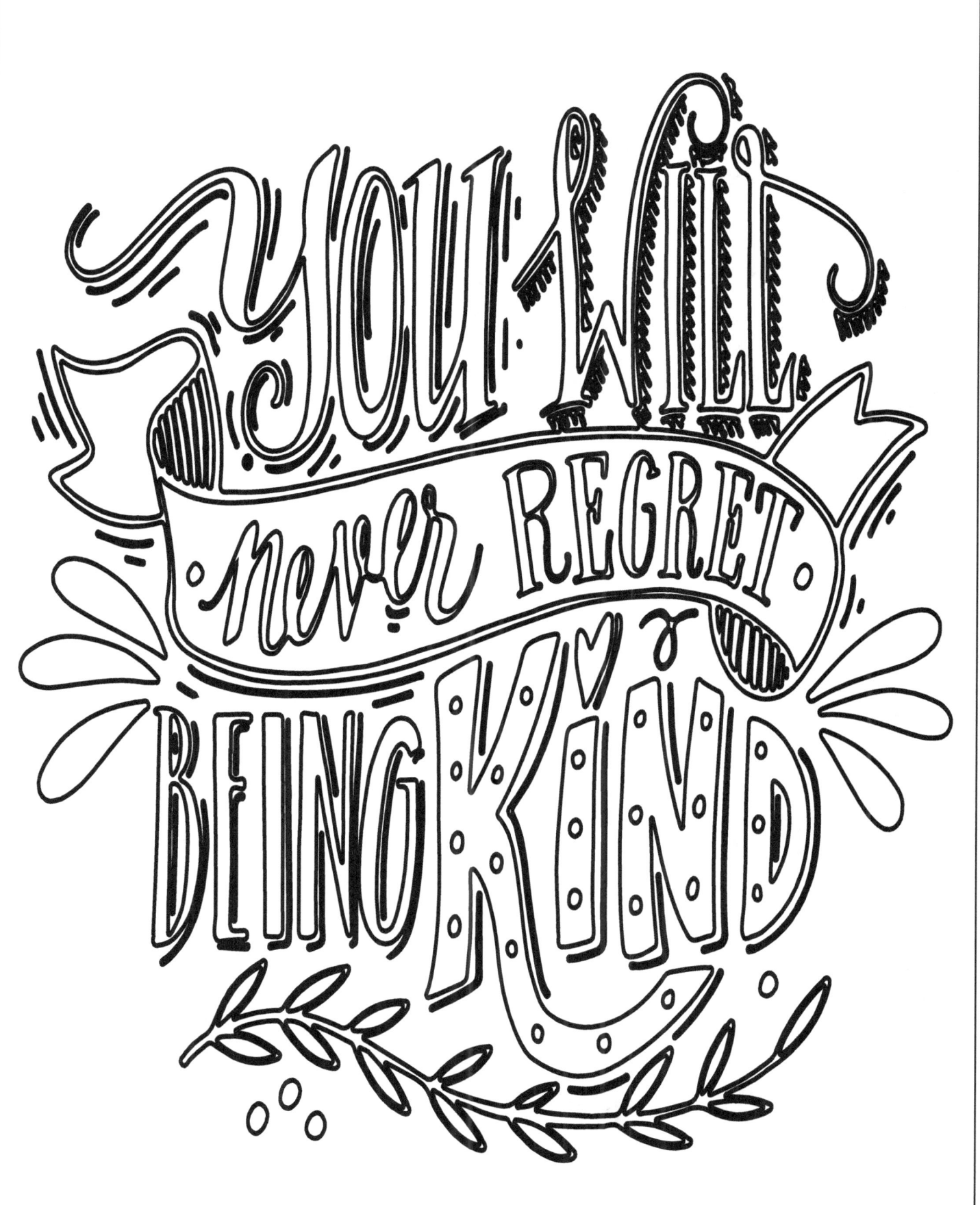

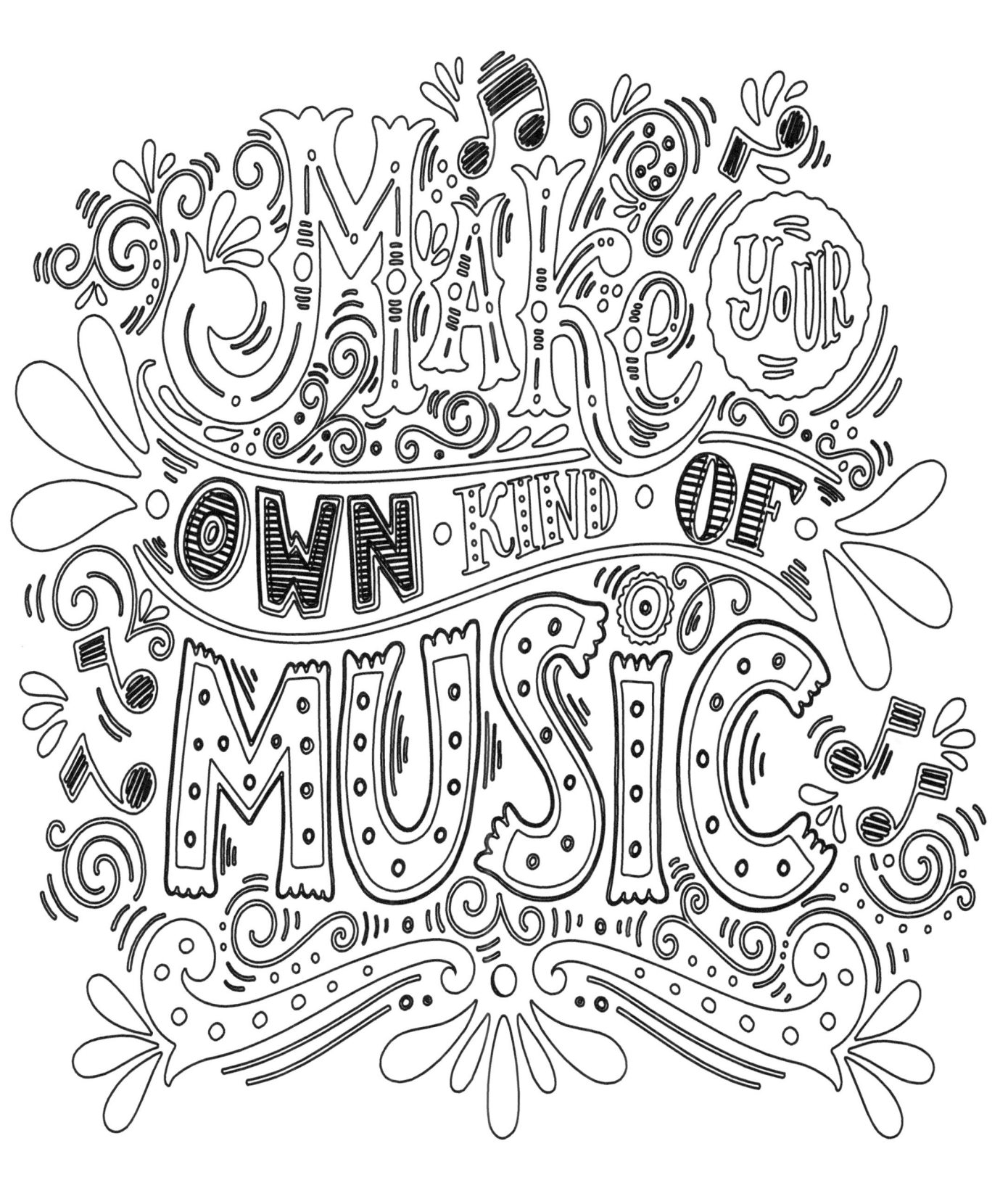

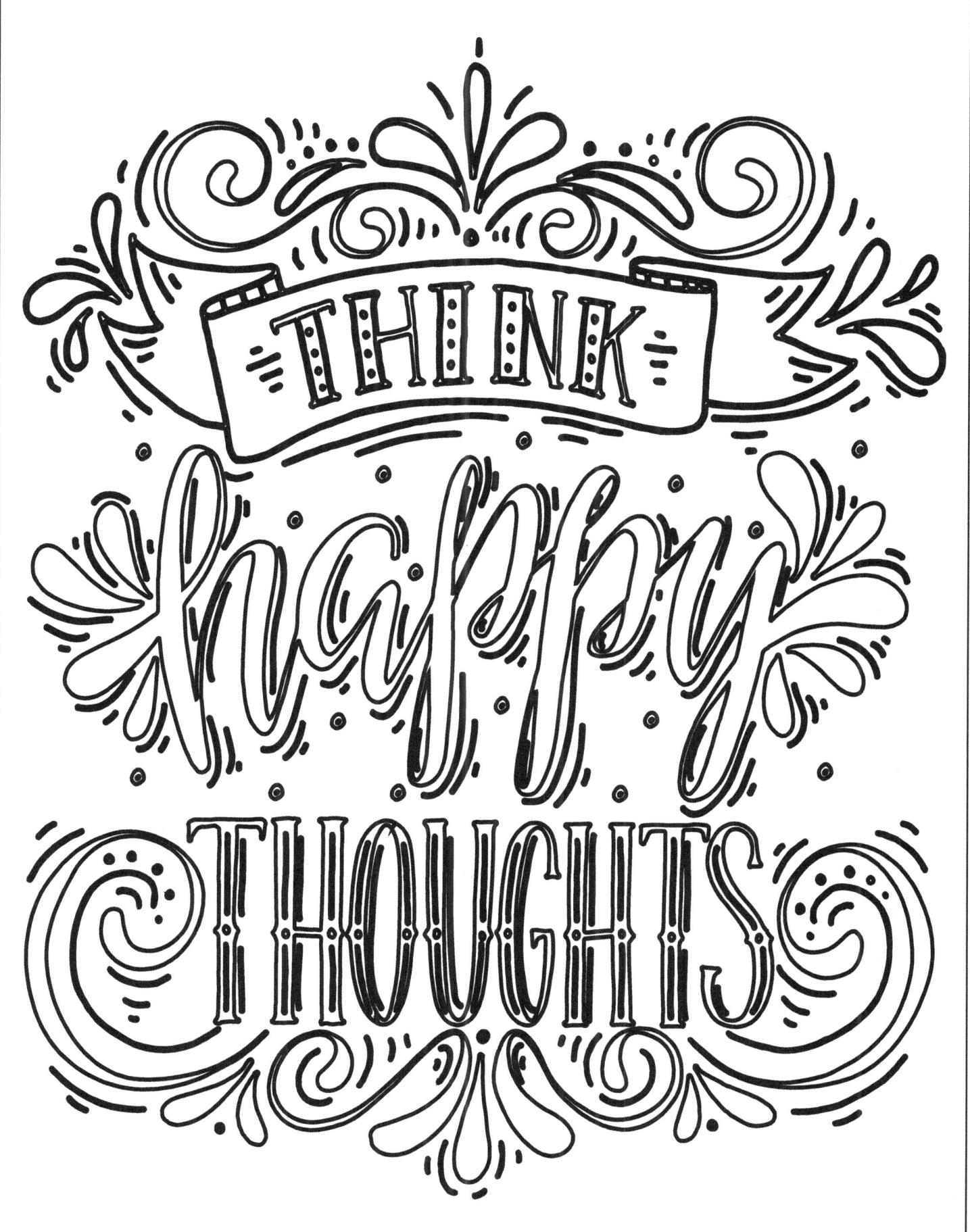

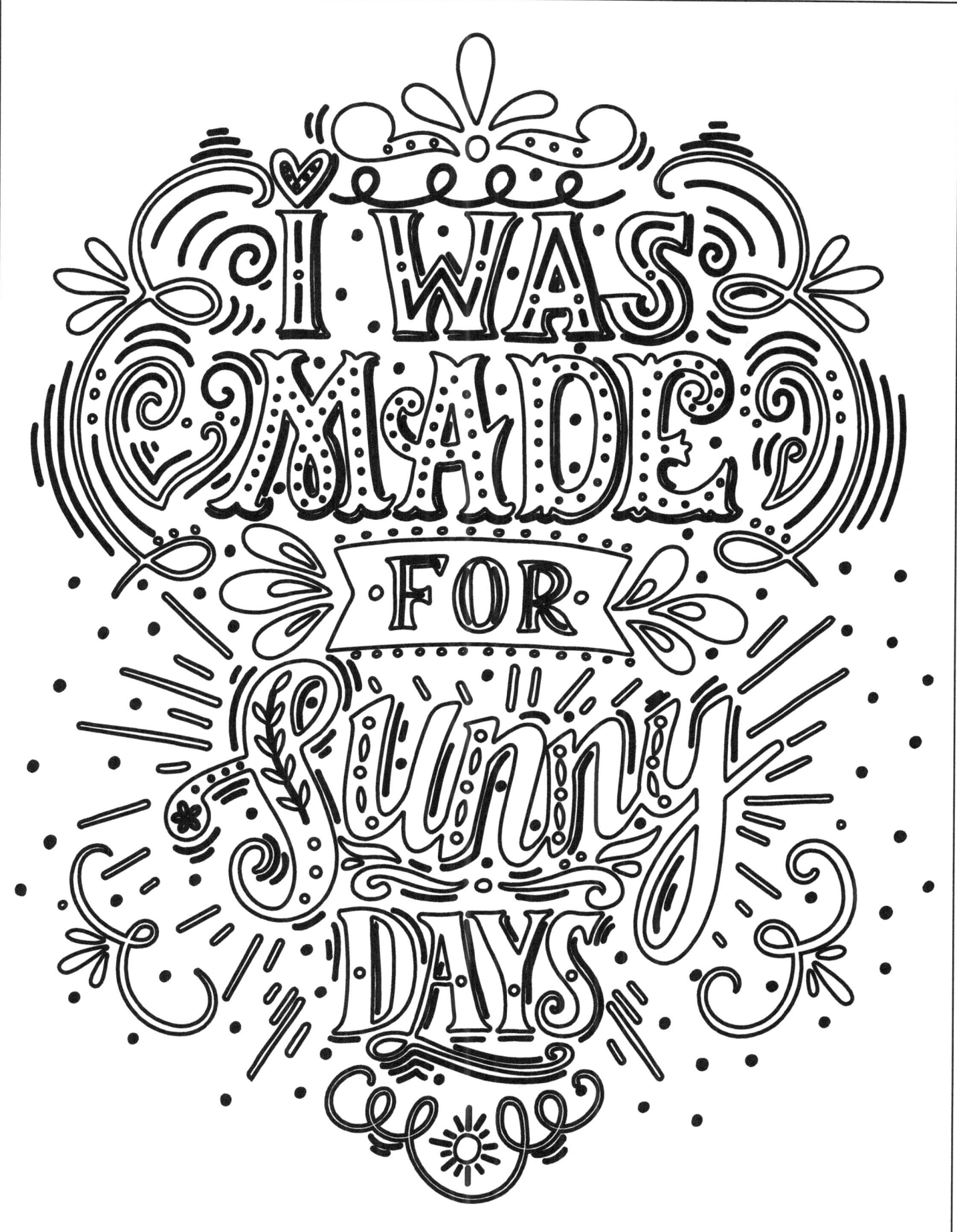

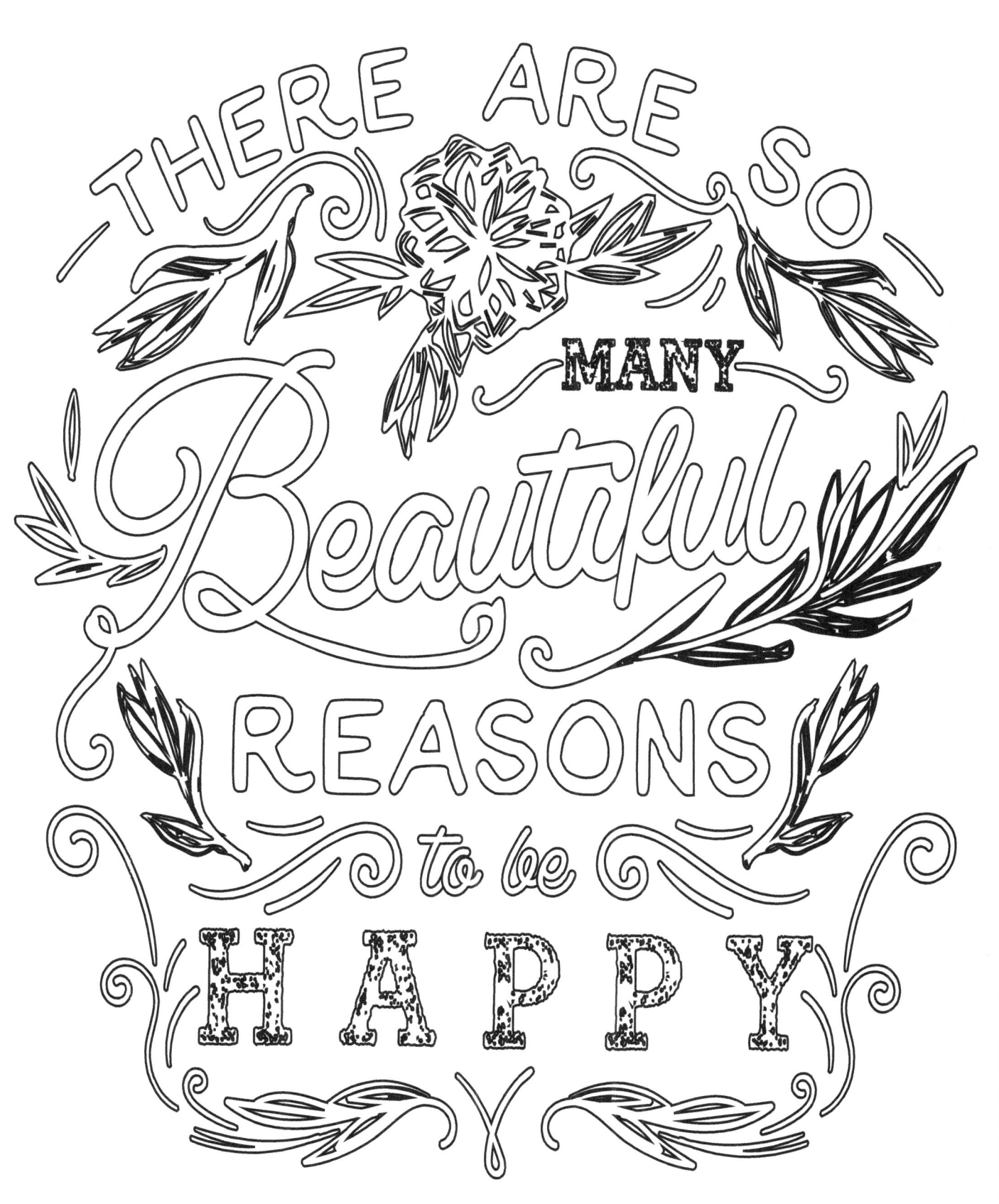

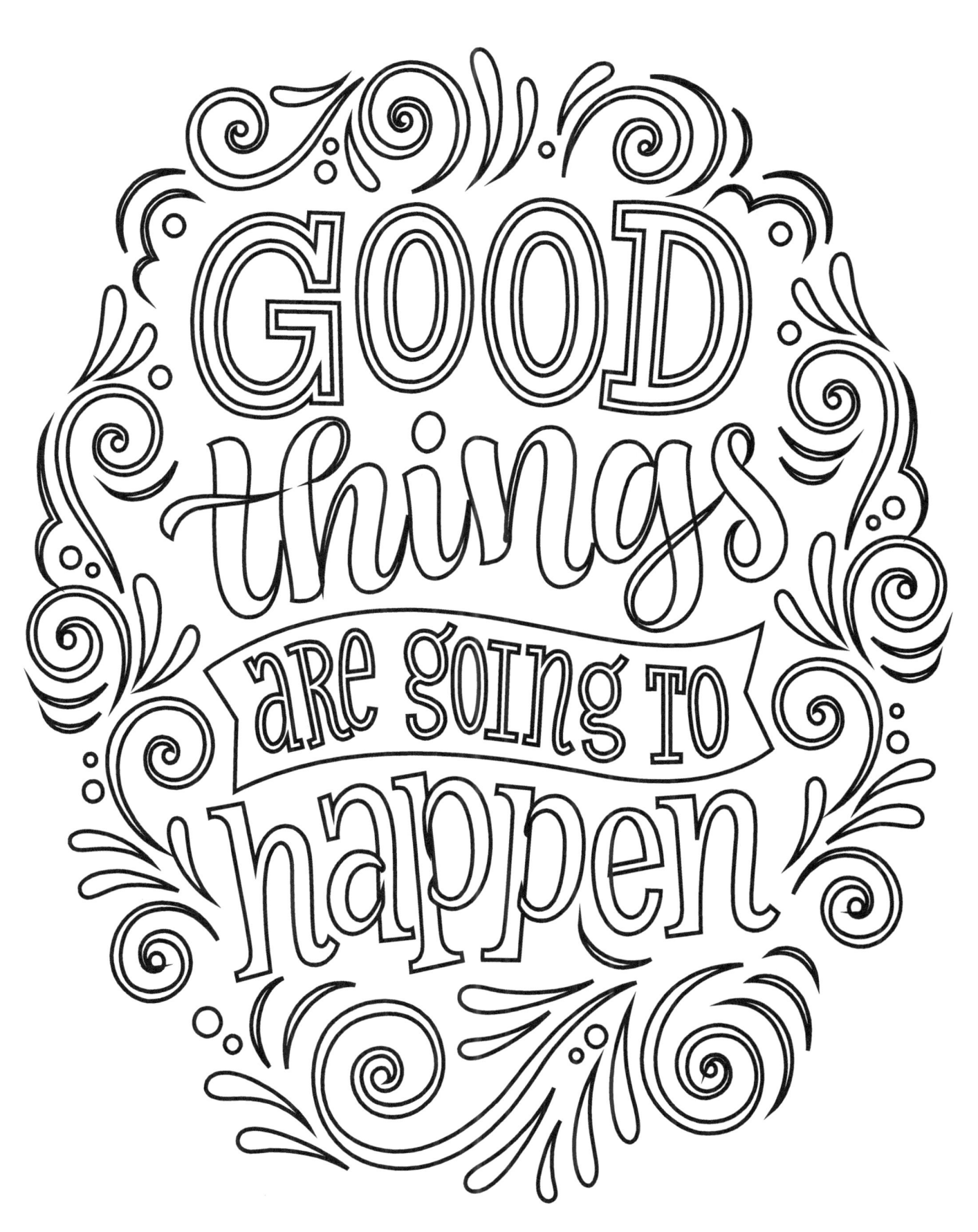

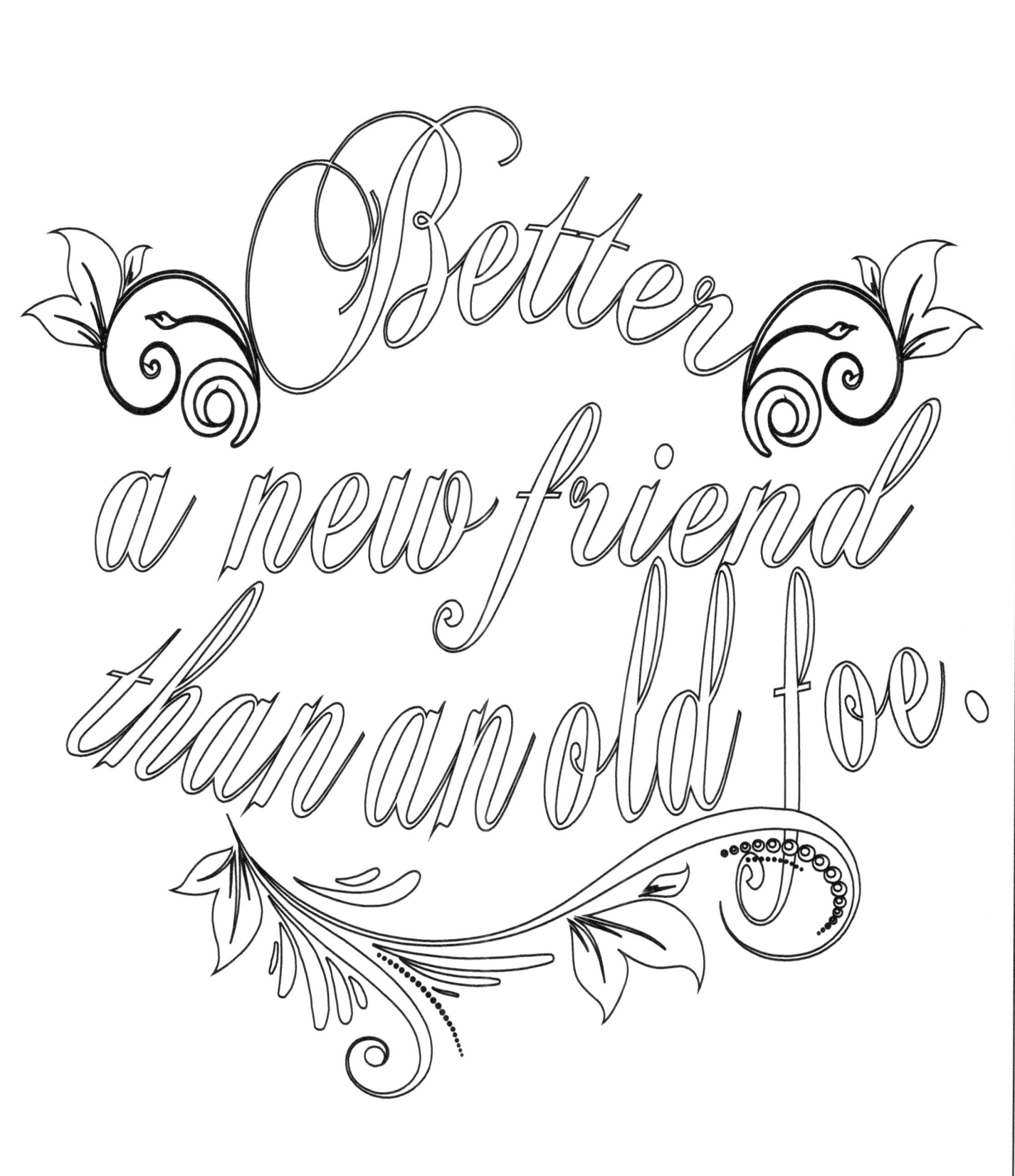

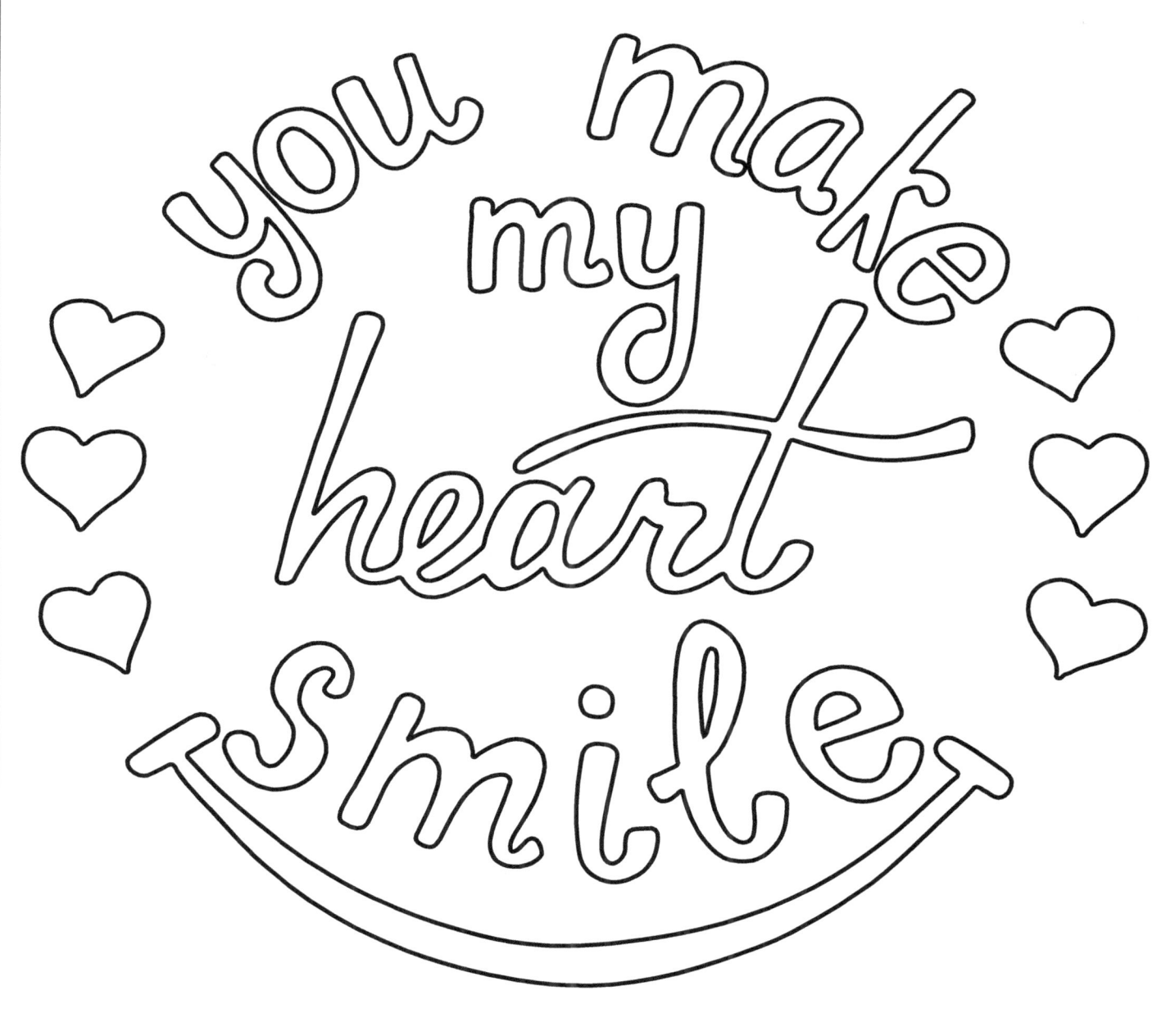

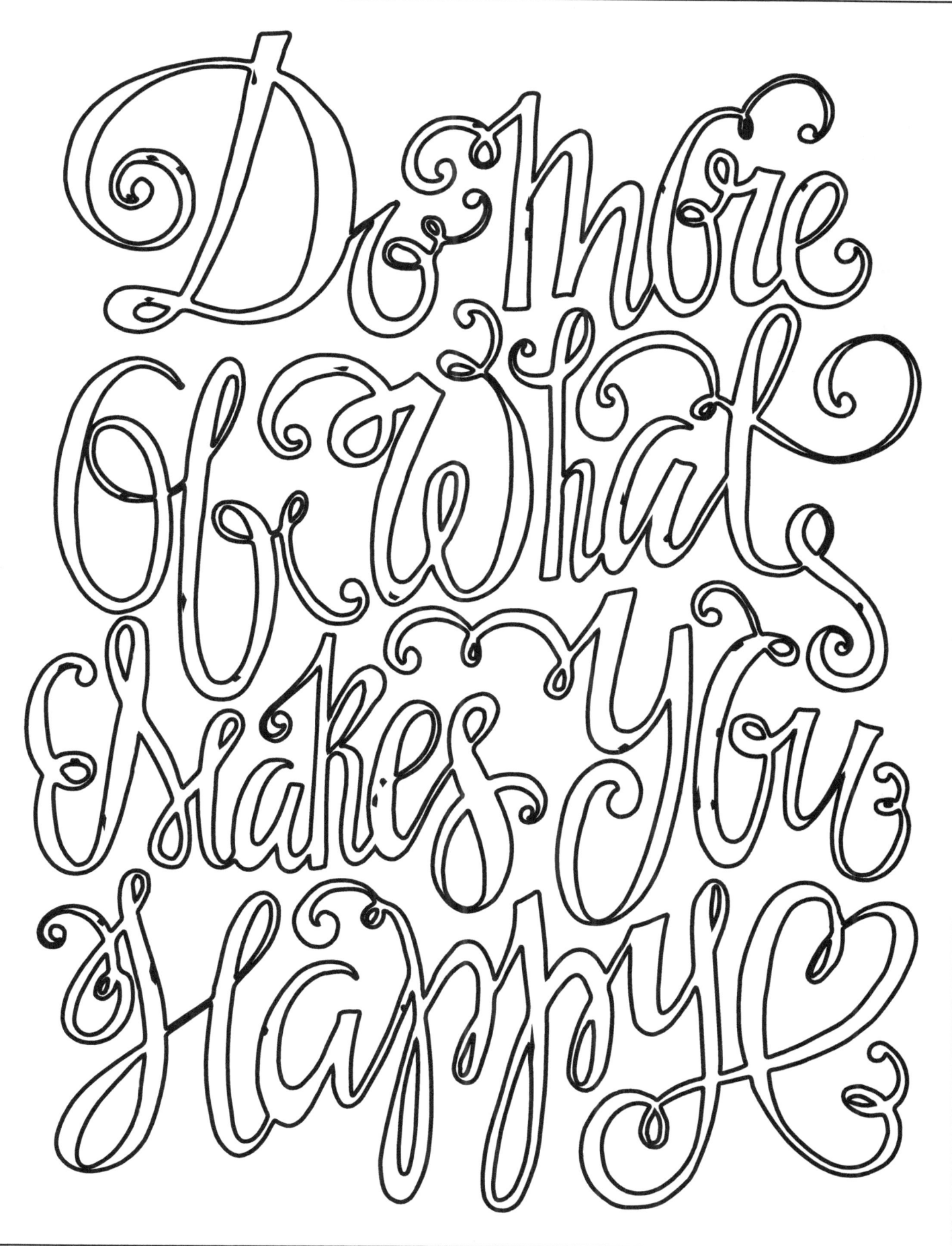

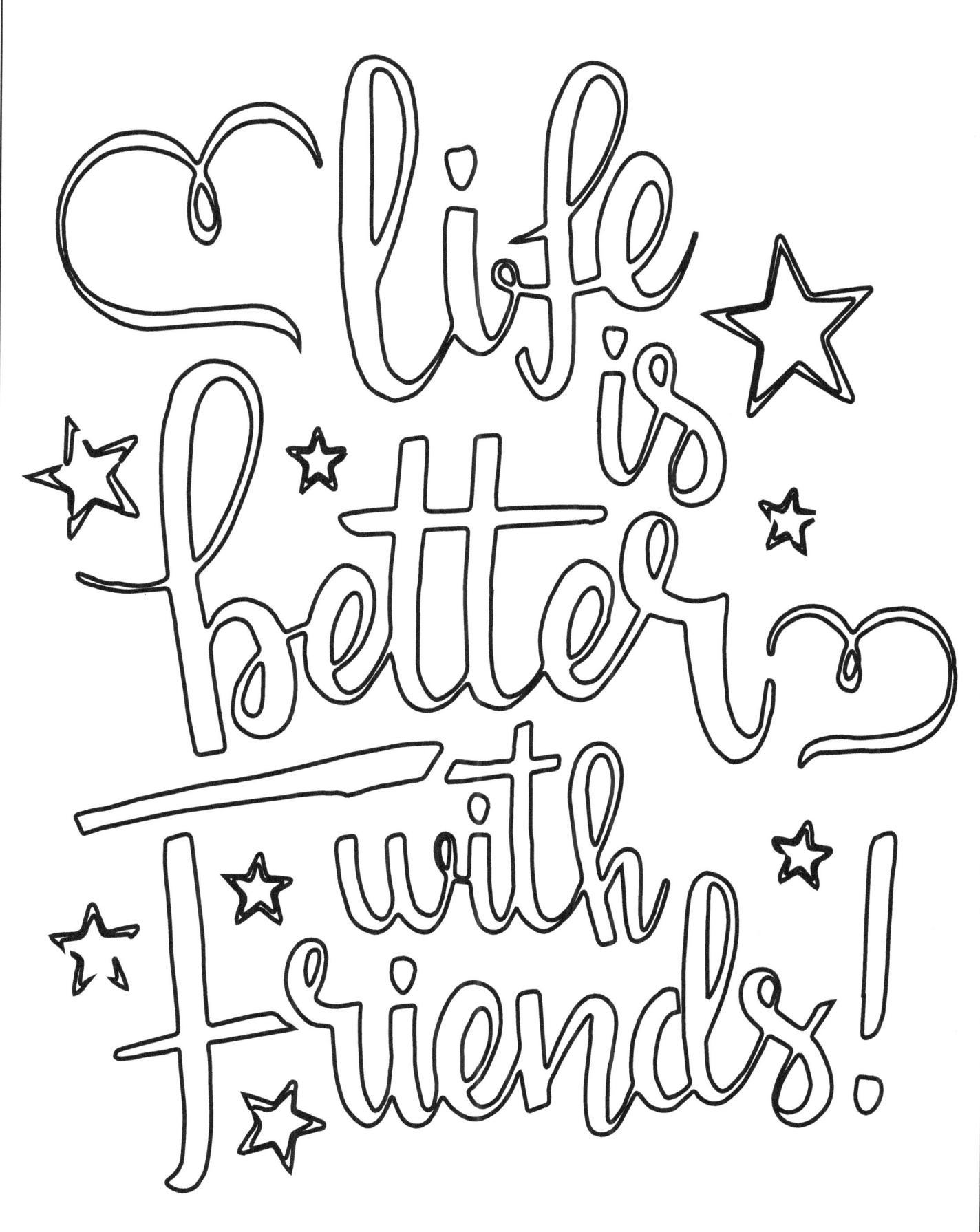

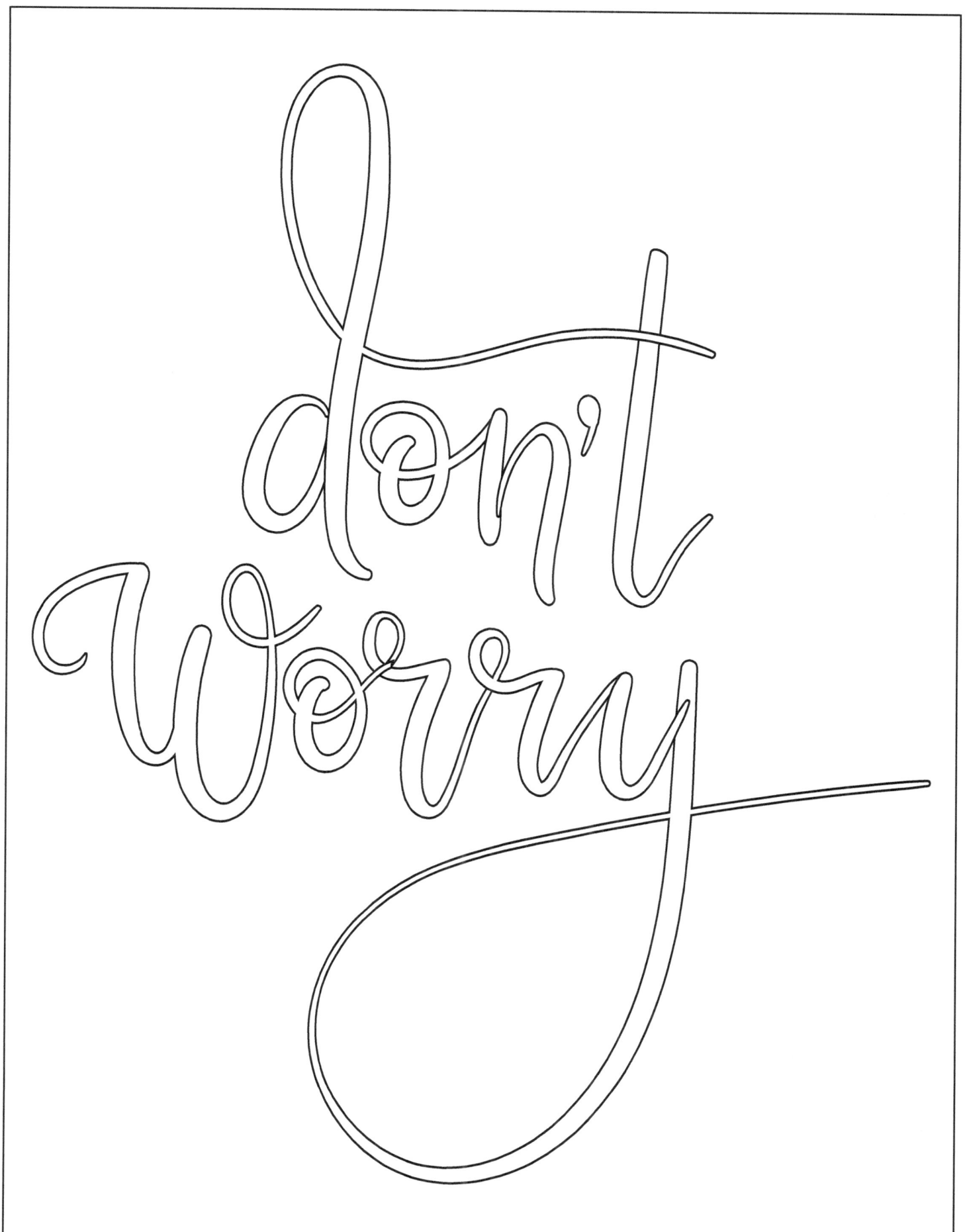

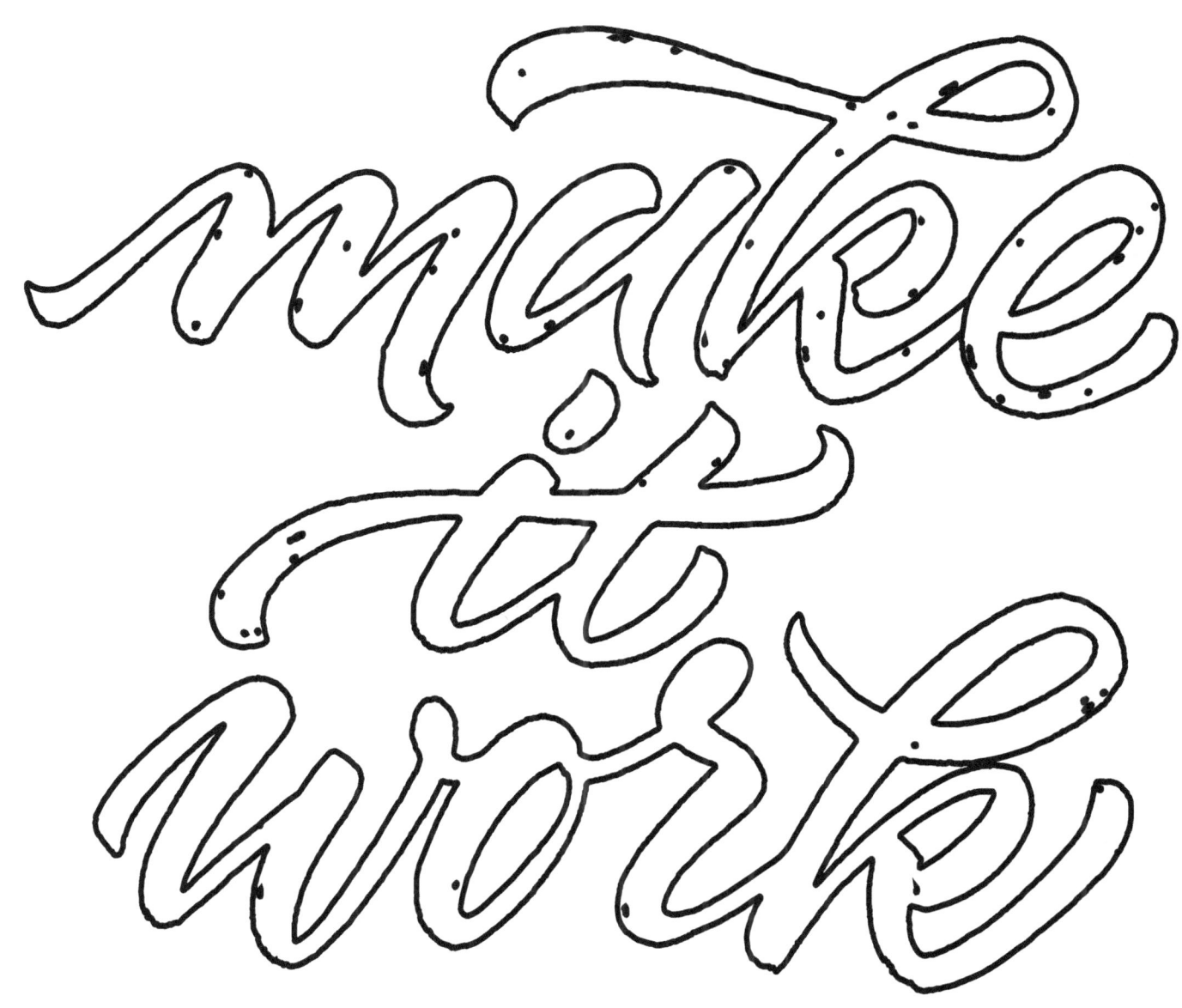

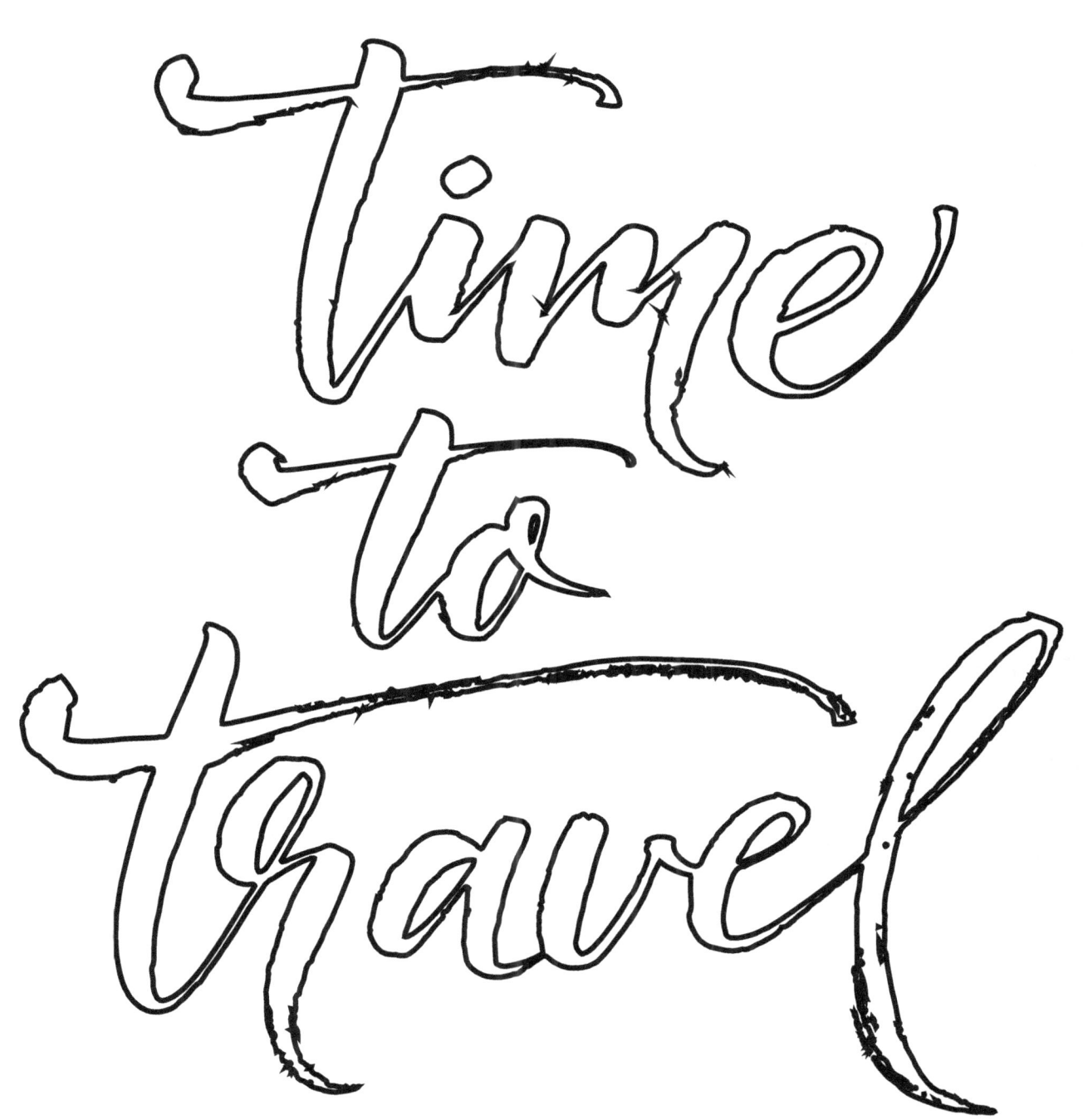

Baby it's Cold Outside

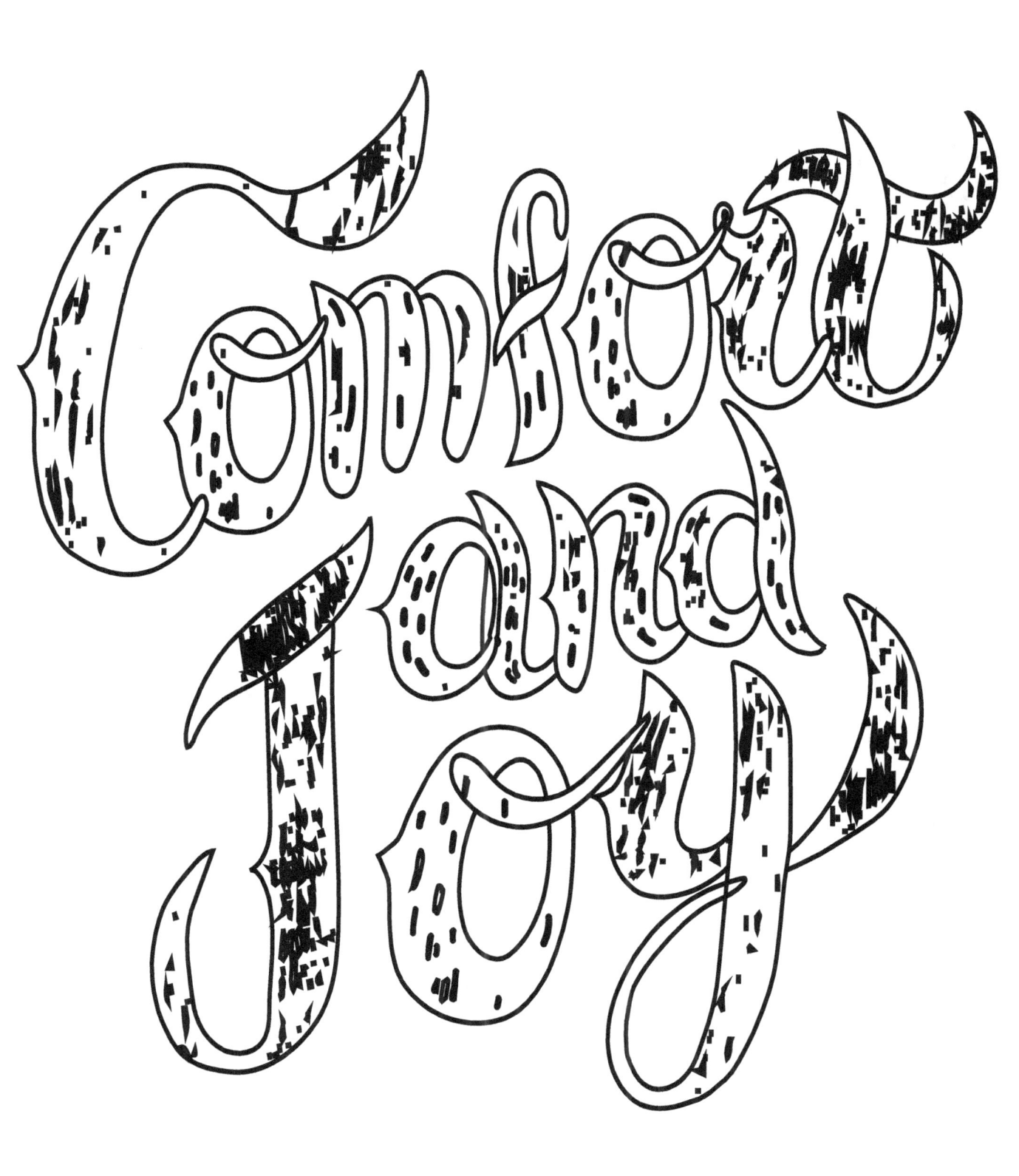

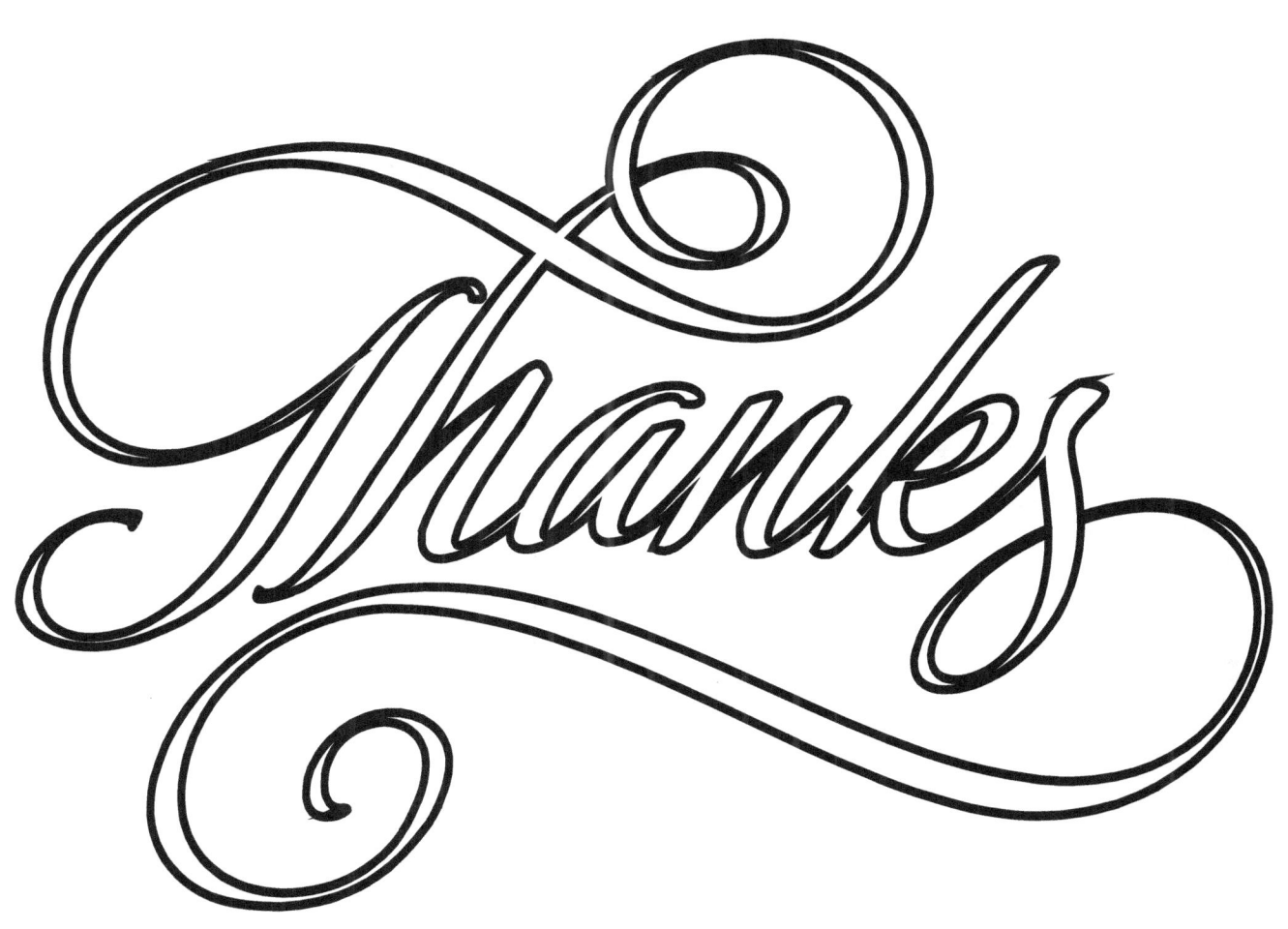

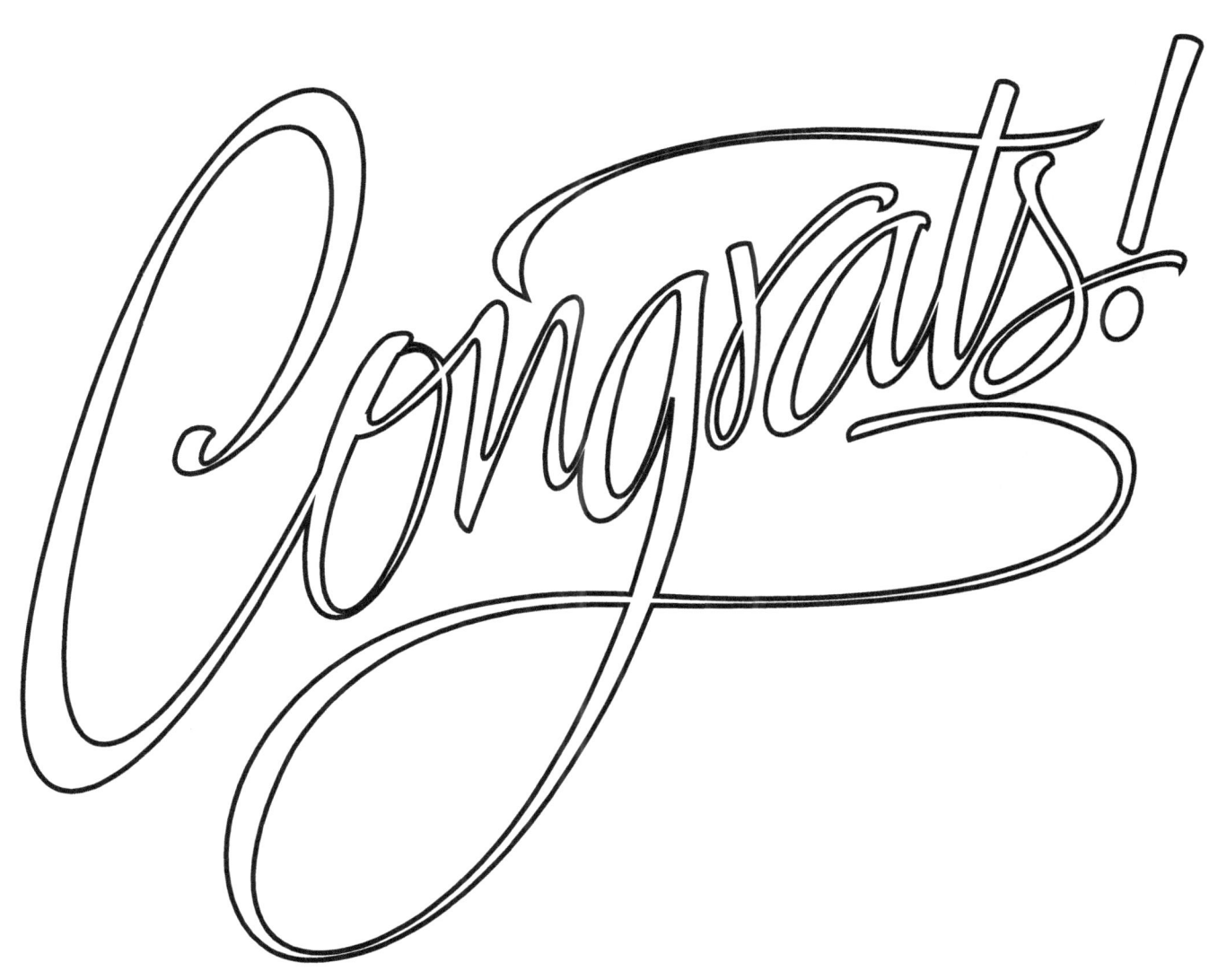

Beautiful things happen when you keep your heart open

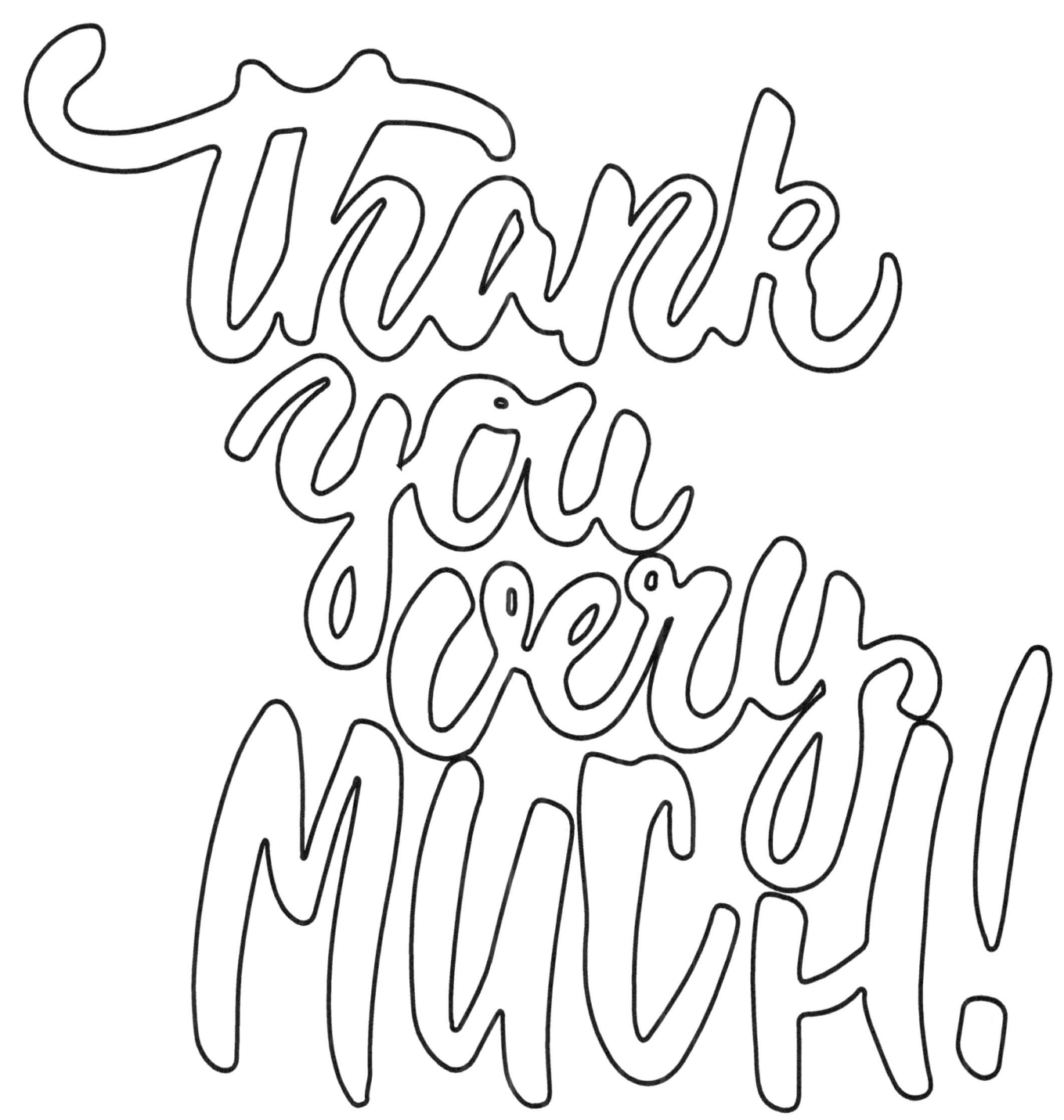

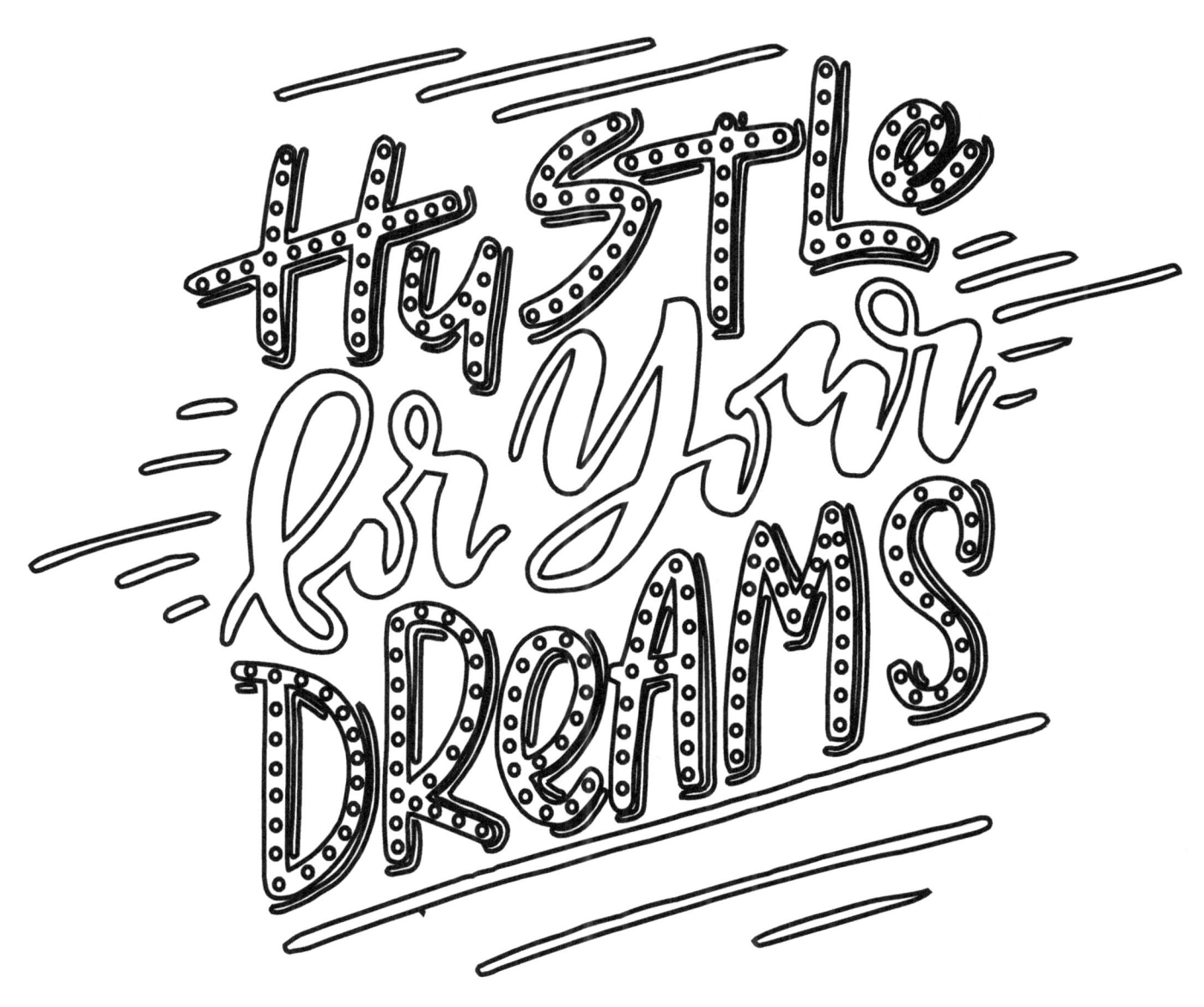

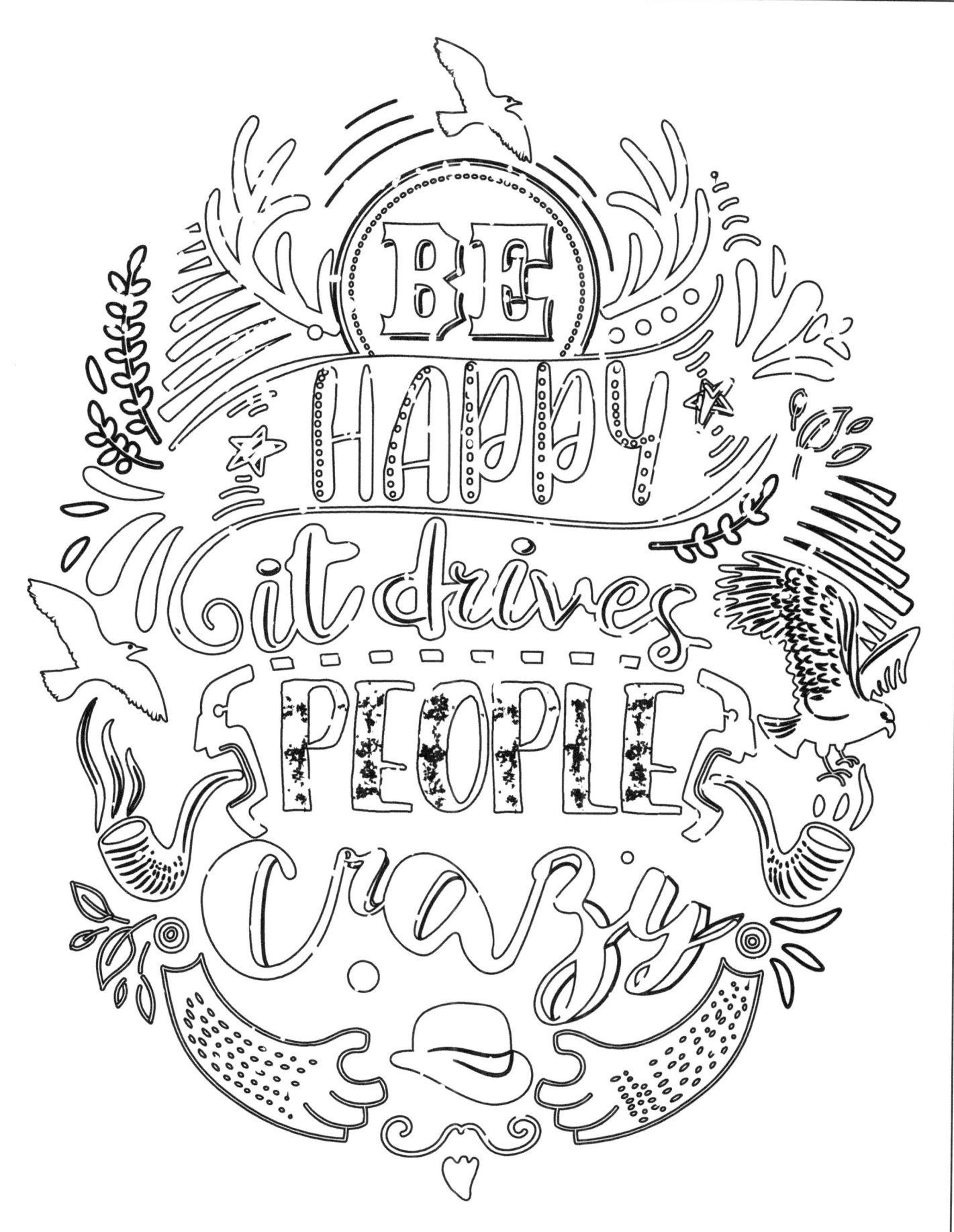

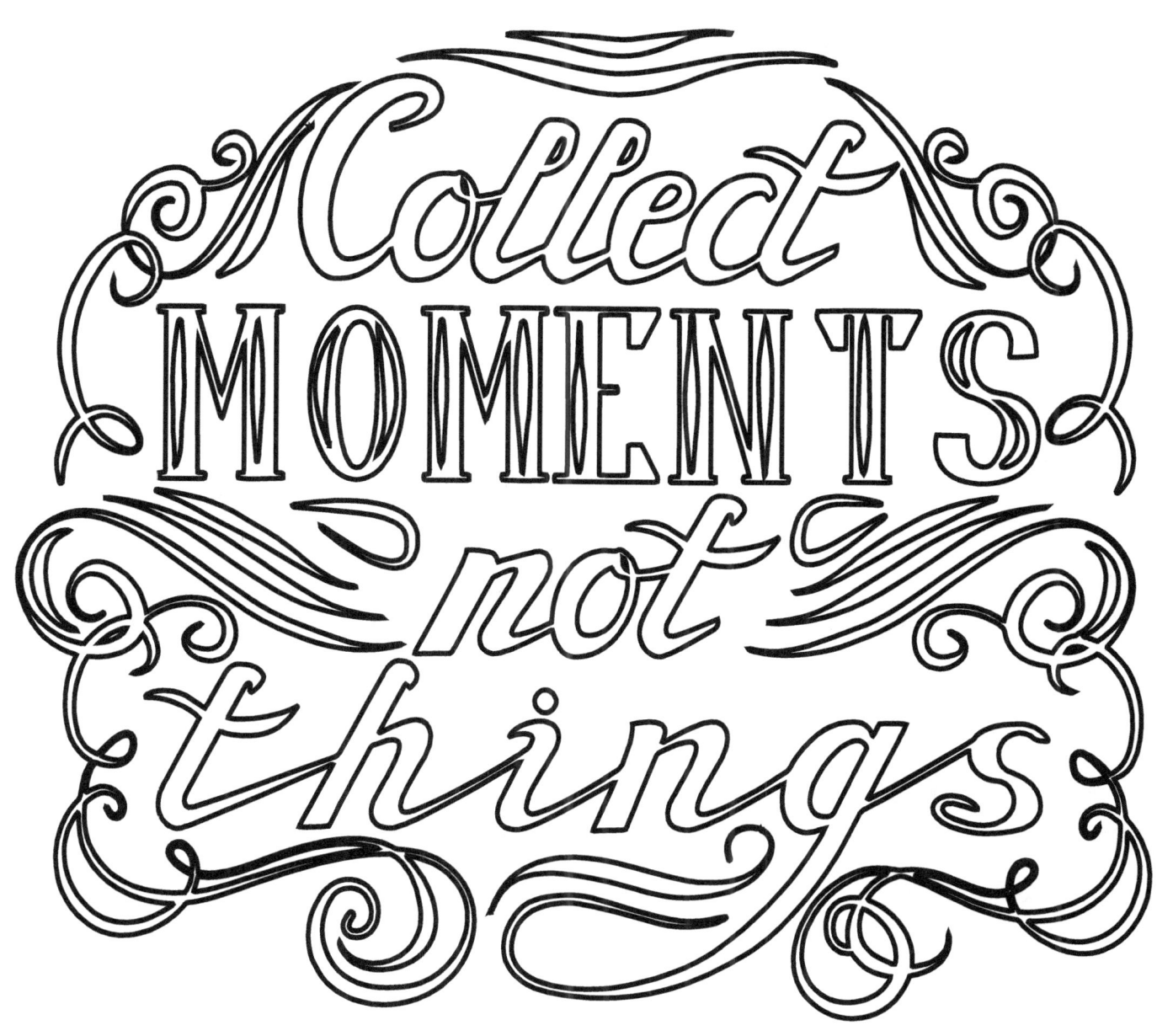

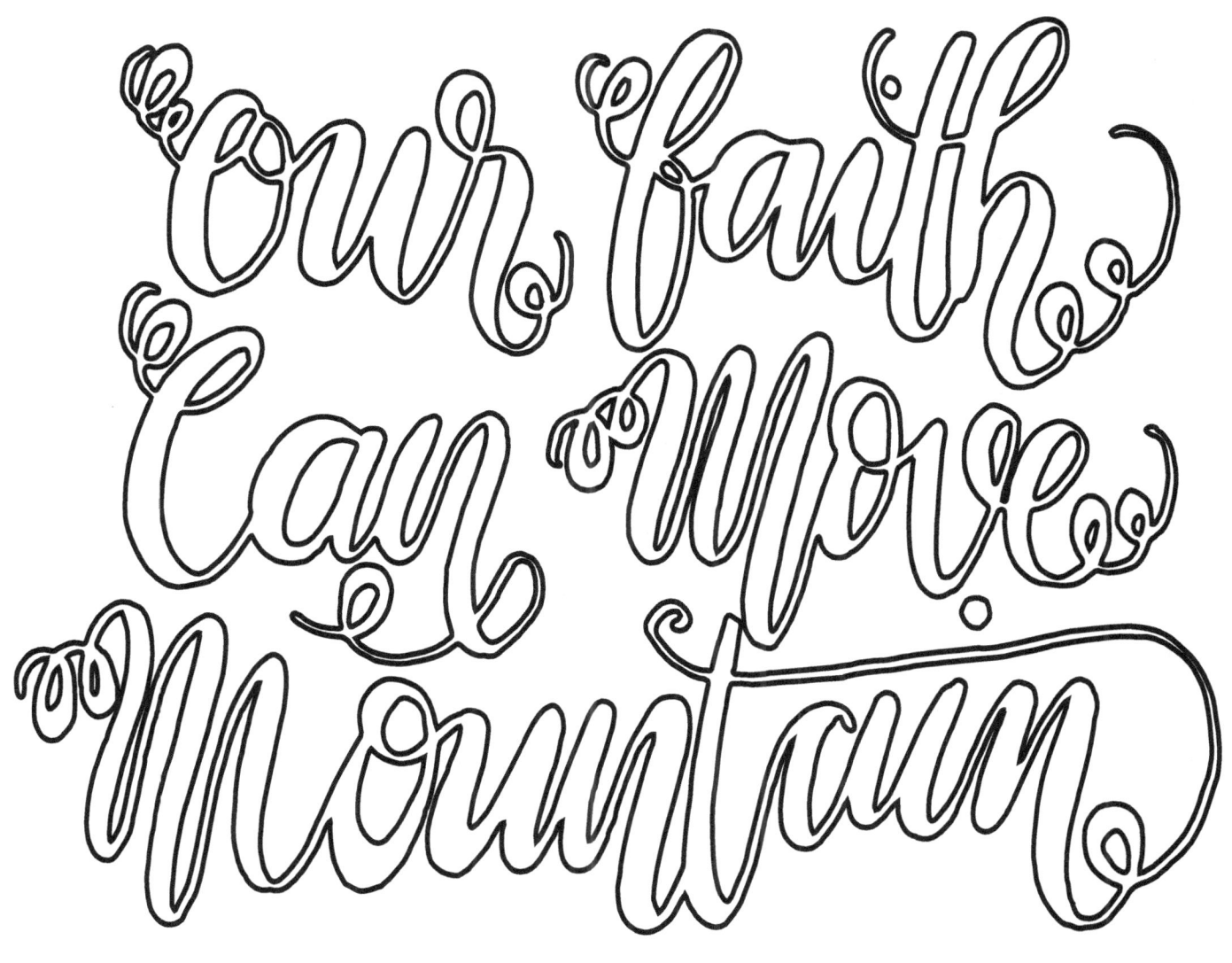

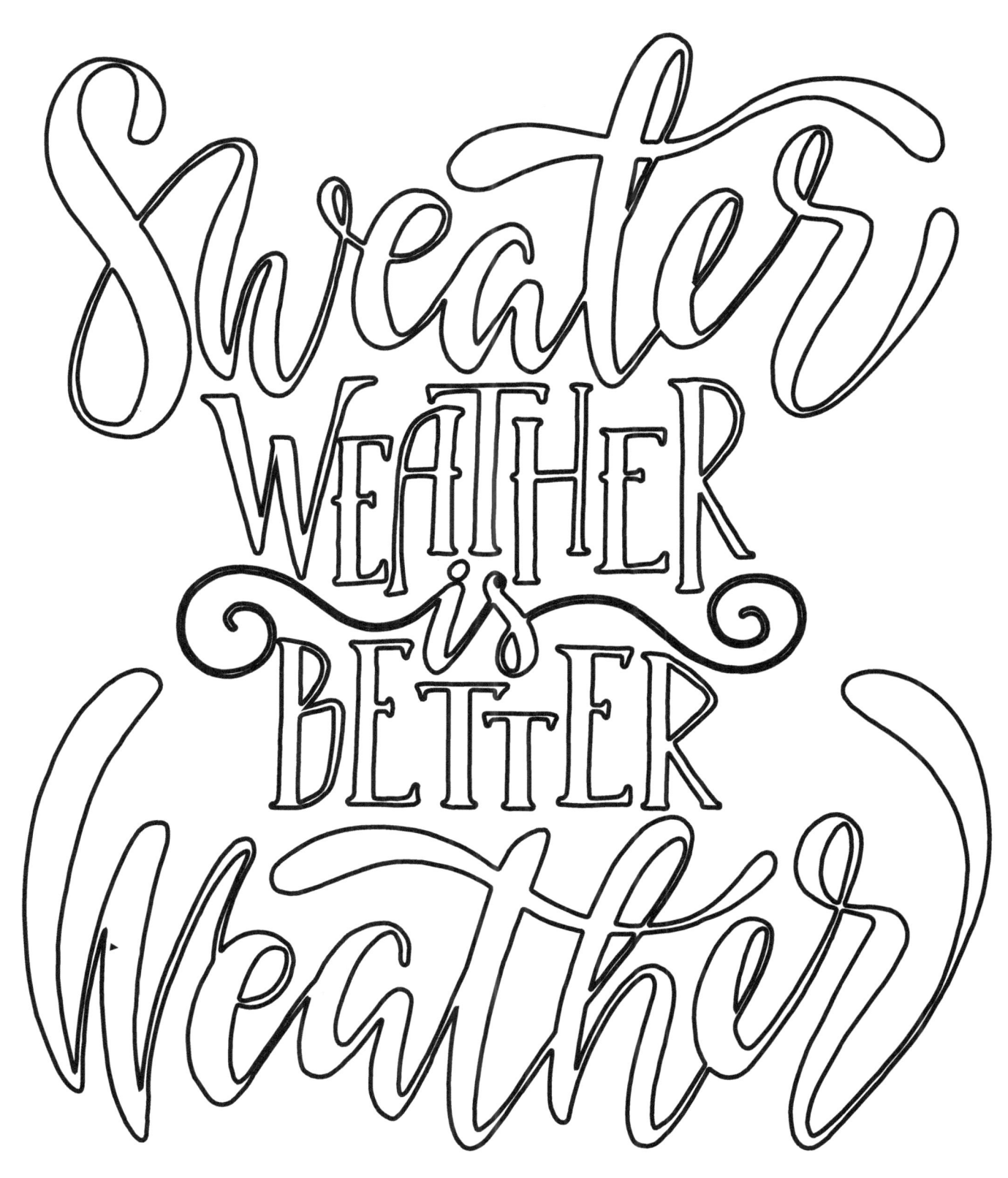

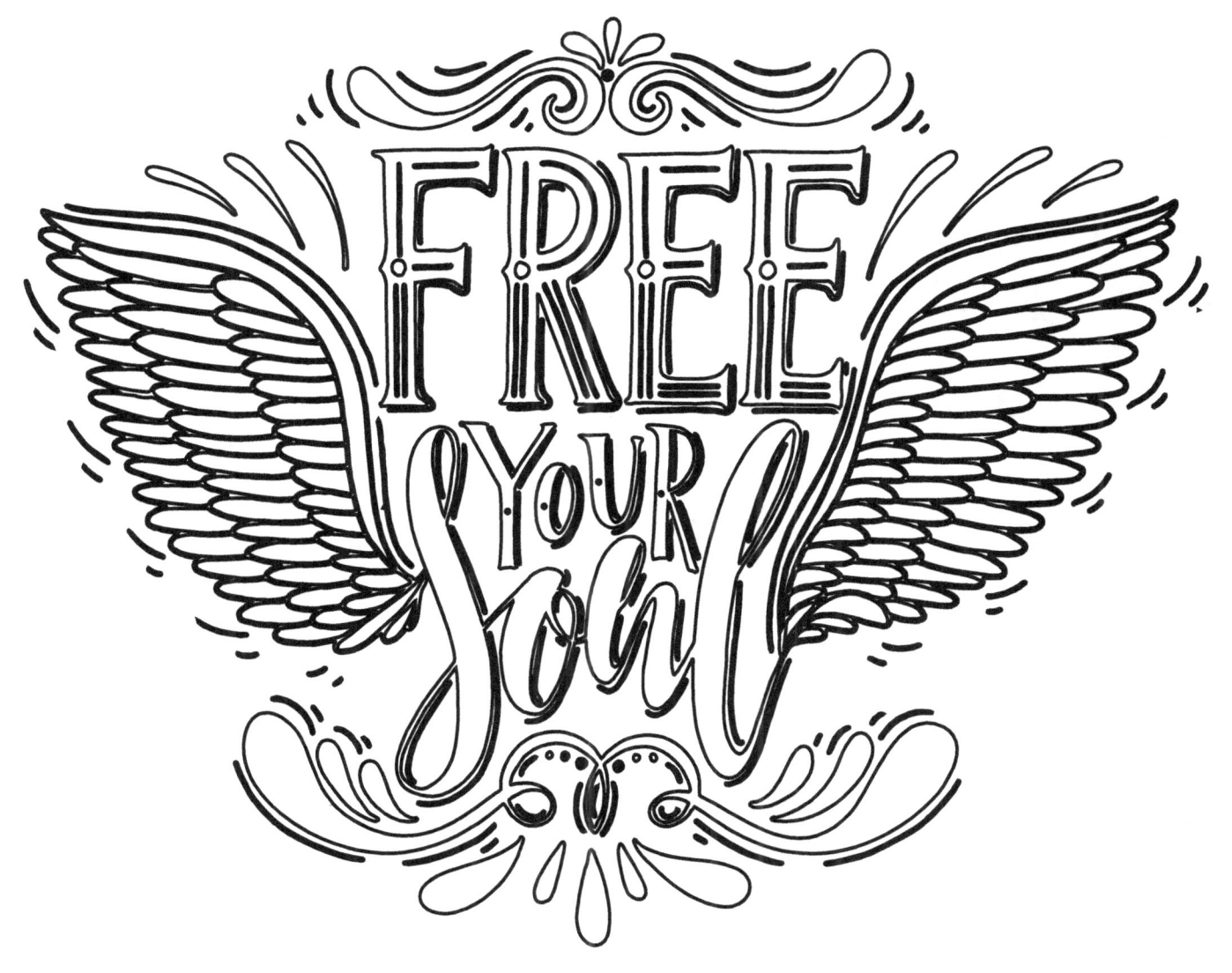

YOU CAN DO *anything* BUT NOT *everything*

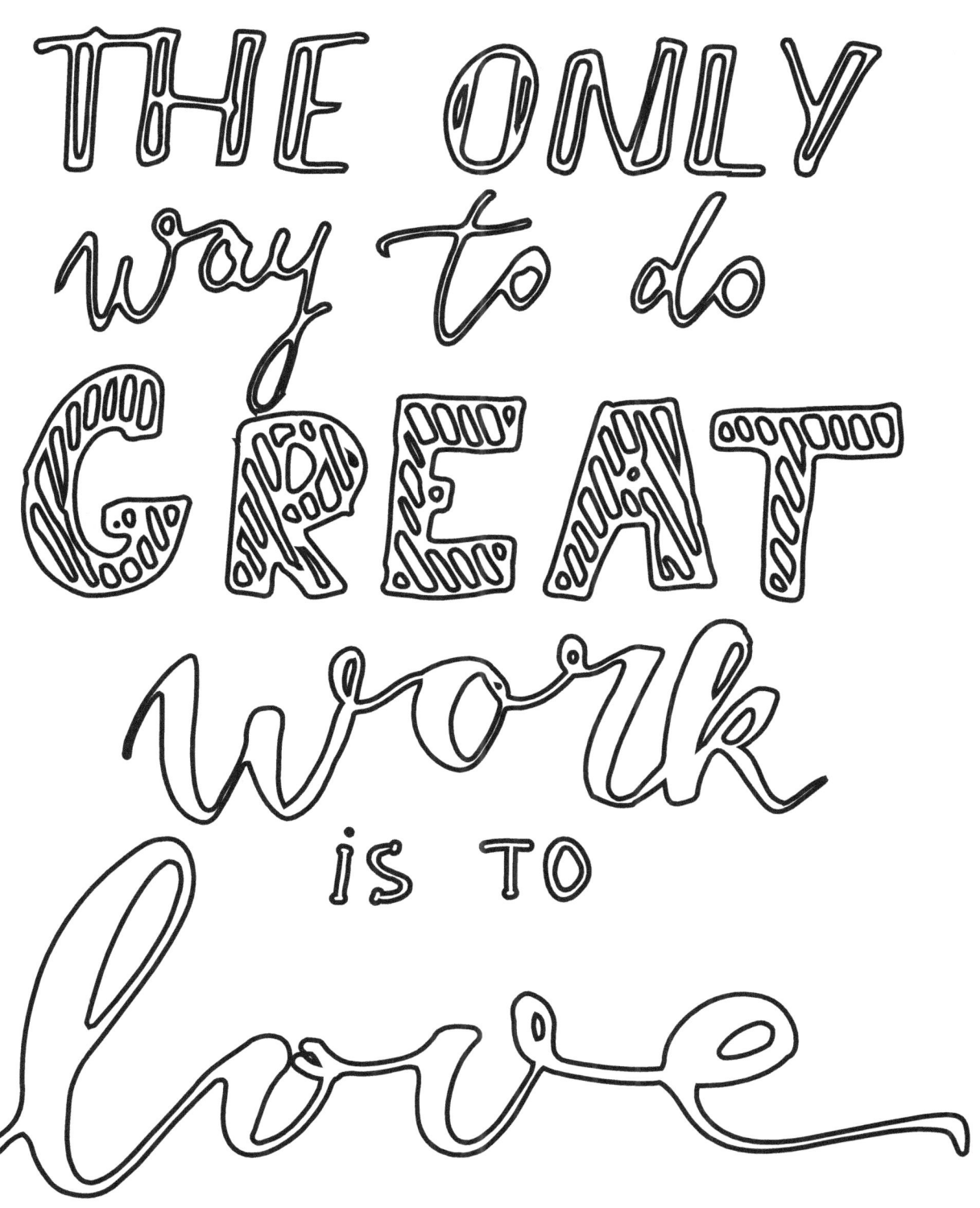

Style is a way to say who you are without having to speak

Don't tell people your dreams. Show them.

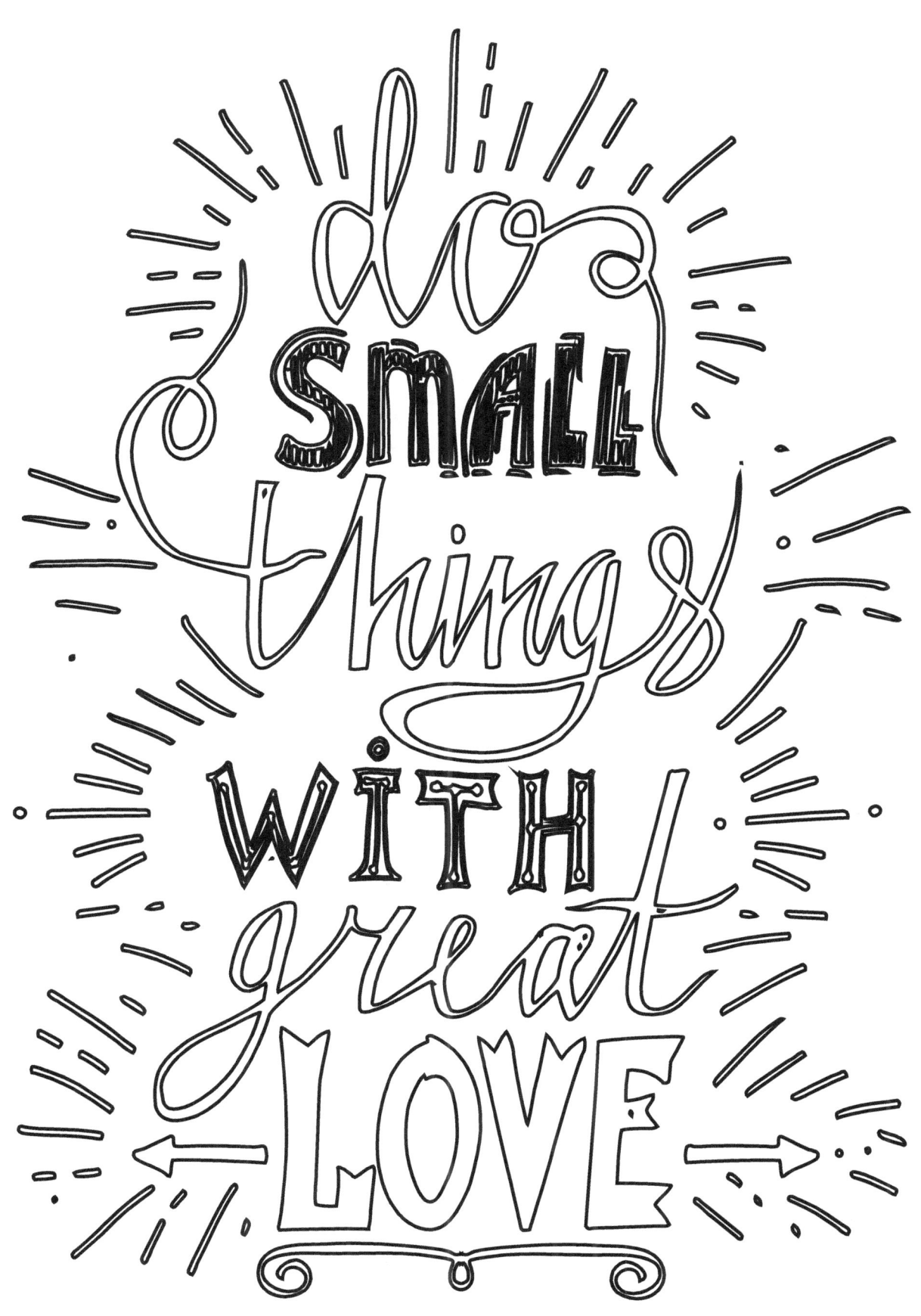

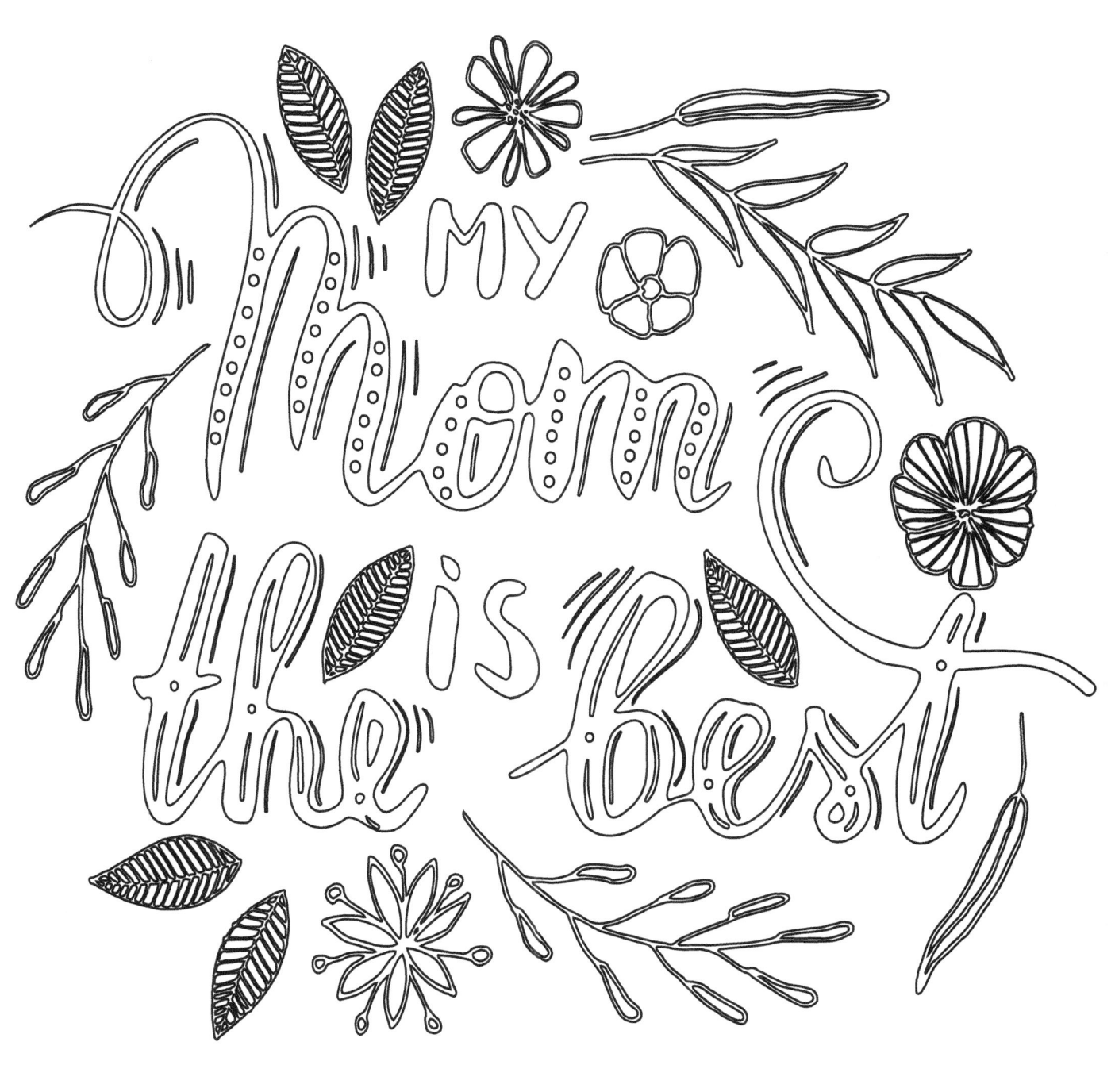

Do it with passion or not at all

Today is Always The Best day

NOT ALL THOSE WHO Wander ARE Lost

You always have time for the things you put first

Books and friends should be few but good

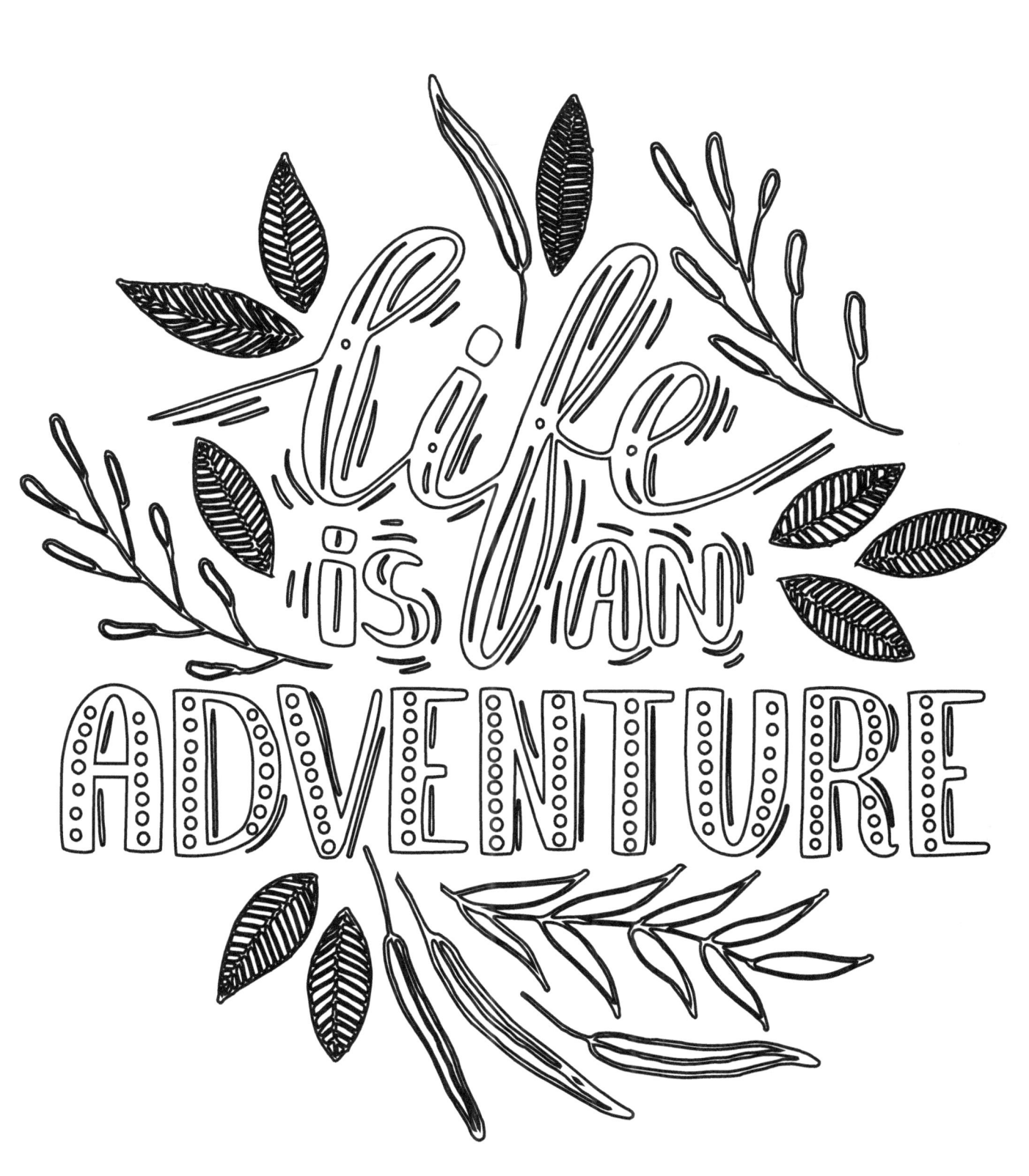

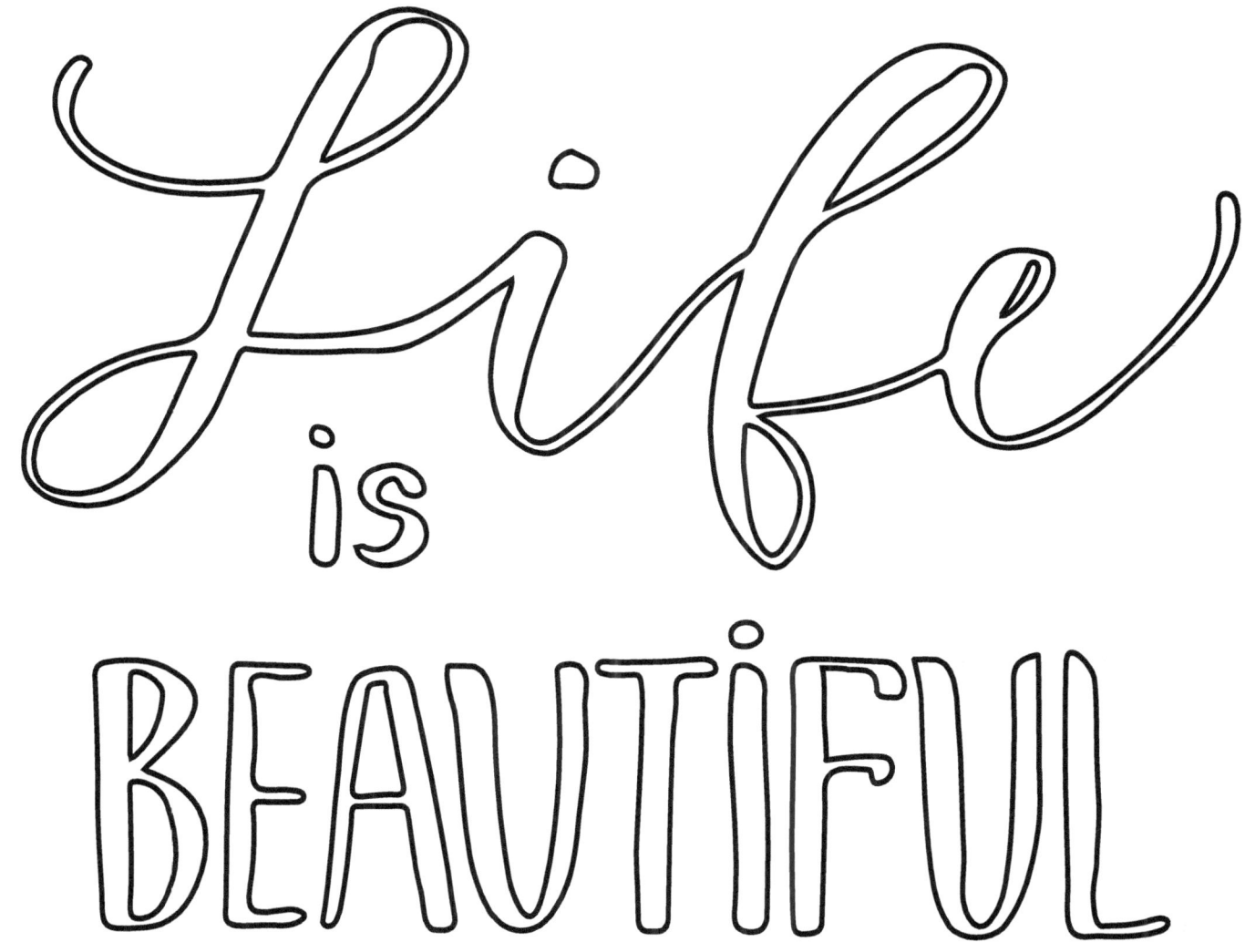

Believe
in yourself

Source Images: credit to - Nina Fedorova, Julia Henze, LOMUD, AnyaS, Bariskina, anmark, ugina, Anastasiia Gevco, FelinaArt, Ollysweatshirt, Anna Kutukova, letterstock, Horst Mickler Graphics, Finevector, Mike McDonald, Courtney Johnson, skopva, Tumana, appler, Alena Gridushko, nellysembiring, Azeriartvector, Maroshka, Fafarumba, Veronika M, Kollibri, Fafarumba, Olga Zakharova, Lawkeeper, Anastasia Panfilova, Glinskaja Olga, 21kompot, Ana Babii

SHOW US YOUR CREATION!

We'd love to hear from you, show us what you created.
Facebook: www.facebook.com/huecoloring
Pinterest: www.pinterest.com/huecoloring

Please be sure to subscribe to our newsletter by visiting: huecoloring.com. We'll show you our latest coloring projects as well as giving you information of the best deals.

www.ingramcontent.com/pod-product-compliance
Lightning Source LLC
Chambersburg PA
CBHW081201180526
45170CB00006B/2182